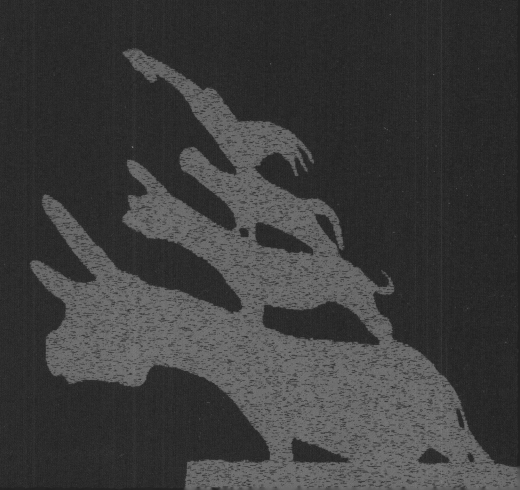

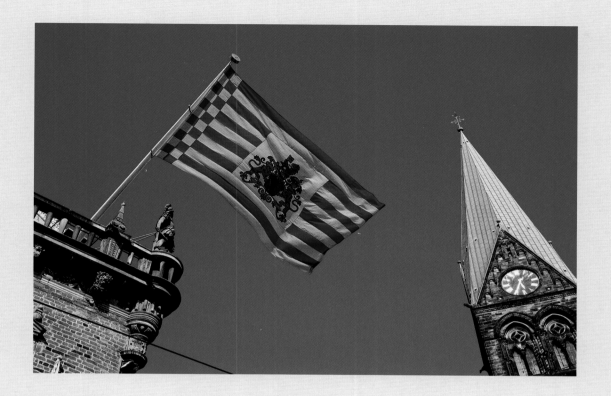

Journey through

BREMEN

Photos by
Günter Franz & Benita Kapur

Text by
Ulf Buschmann

Stürtz

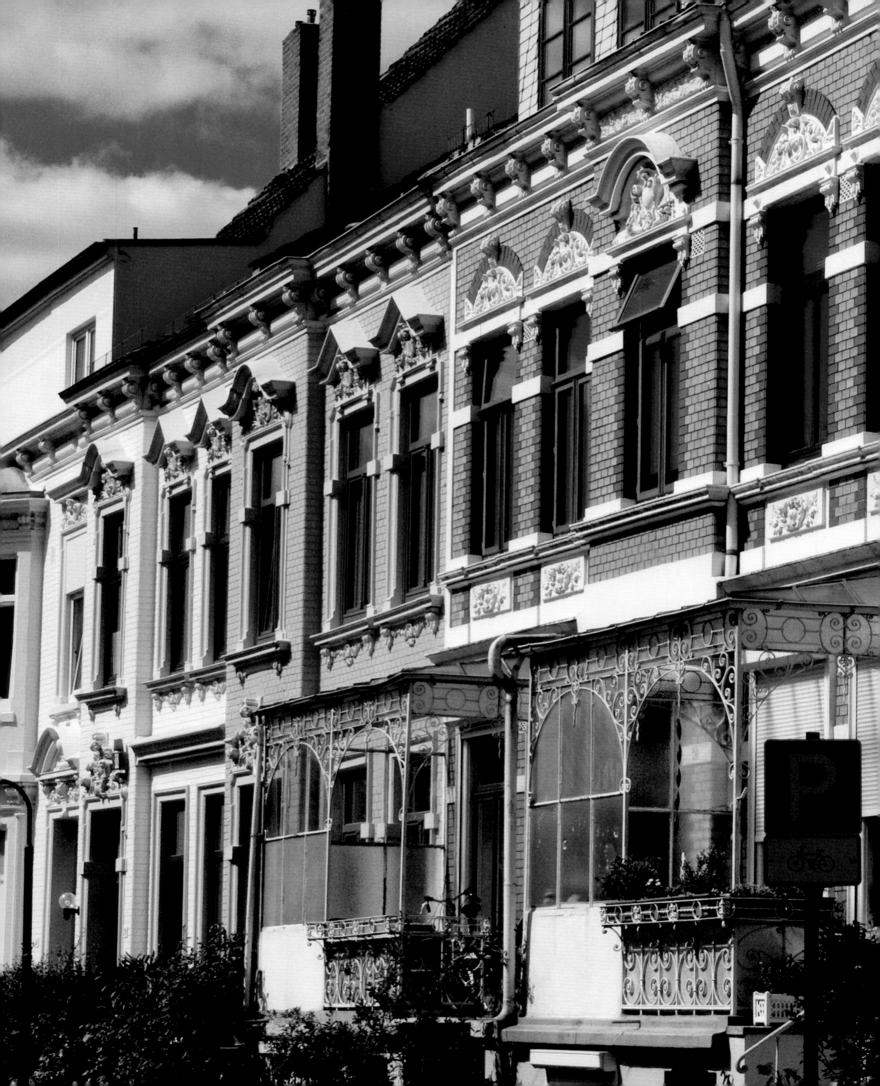

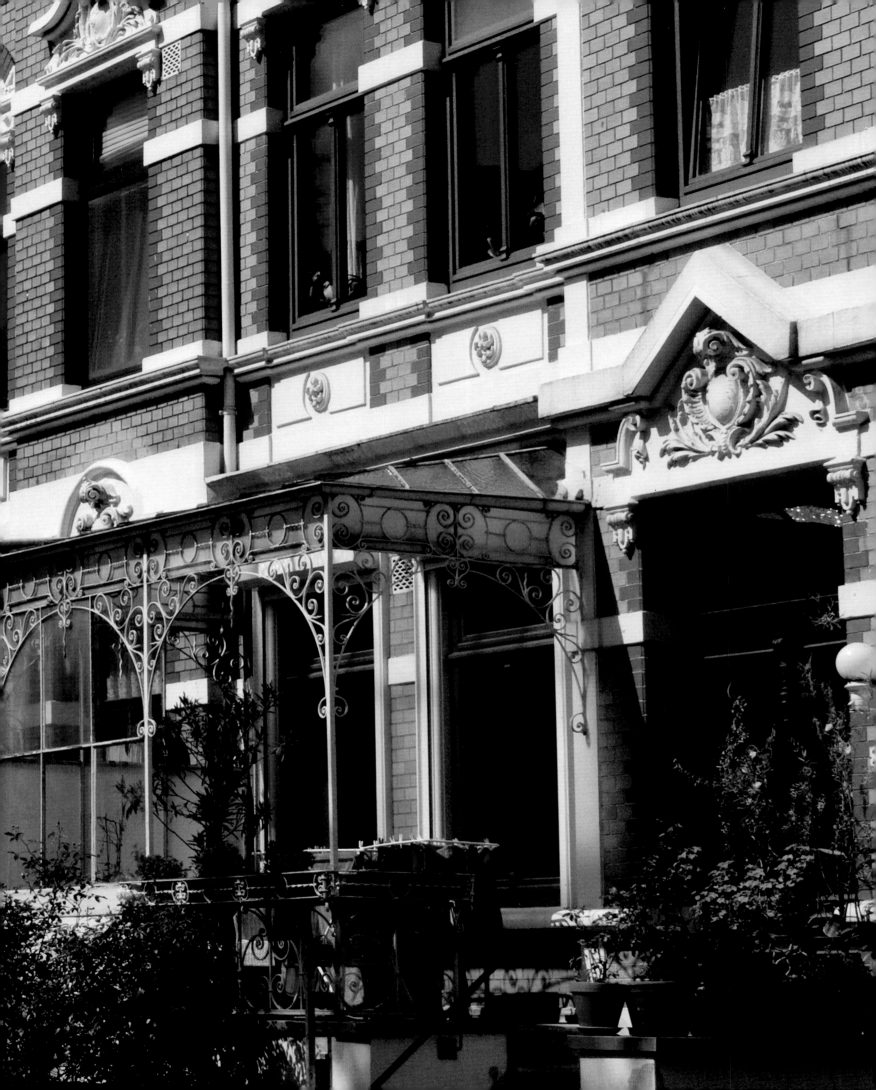

First page:
On official occasions the flag is raised above the Rathaus or town hall in Bremen. Its red and white stripes and cubes have earned it the nickname "bacon flag". The state coat of arms with its two keys and three lions adorns the centre.

Previous page:
This terrace is a typical example of the Bremer Haus, found in this form only in Bremen. Streets of houses like these were built between 1880 and 1930 and many boasted a spacious conservatory.

Below:
There are many pleasant little villages in the area around Bremen, such as the former artists' colony of Fischerhude whose development was inextricably linked to that of Worpswede. One of the most popular venues here is Körbers Gasthof.

Page 10/11:
Neuer Hafen or the new harbour in Bremerhaven is proving to be a huge tourist magnet. Where emigrants once set off for America, visitors can now explore a number of attractions, including the Columbus Centre (centre), the German Museum of Shipping (right), a museum of emigration (Deutsches Auswandererhaus), a zoo and, new in 2009, the Klimahaus on the climate of our planet.

Contents

12

**Bremen –
a village with trams**

26

**From the marketplace
to the Weser –
the city centre**
Page 62
Bremen architecture –
two unique examples
Page 80
Brown cabbage,
sausage and scouse:
culinary Bremen

86

**From the Lesum
to Nordenham –
the environs**
Page 104
Artists' colony on a devil's
moor – Worpswede
Page 114
Artists' colony on the
Wümme – Fischerhude

120

**Harbouring history
in Bremerhaven**

134 Index
135 Map
136 Credits

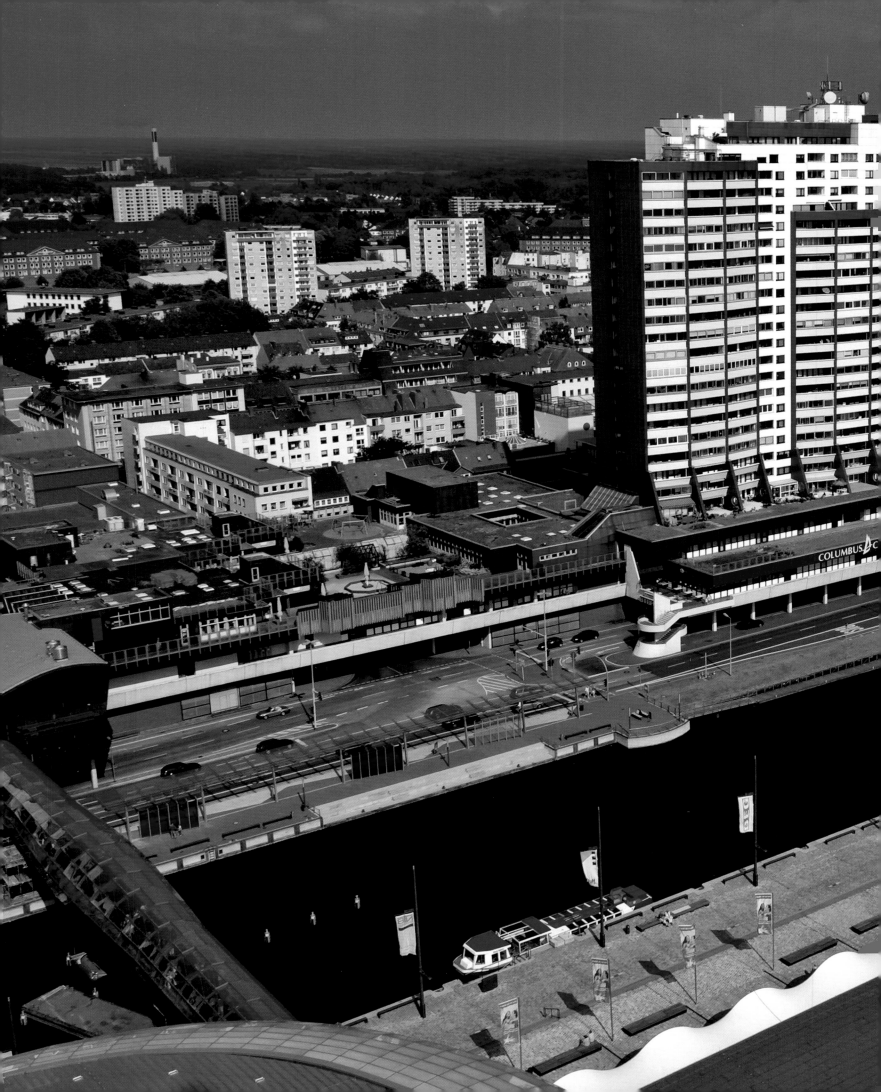

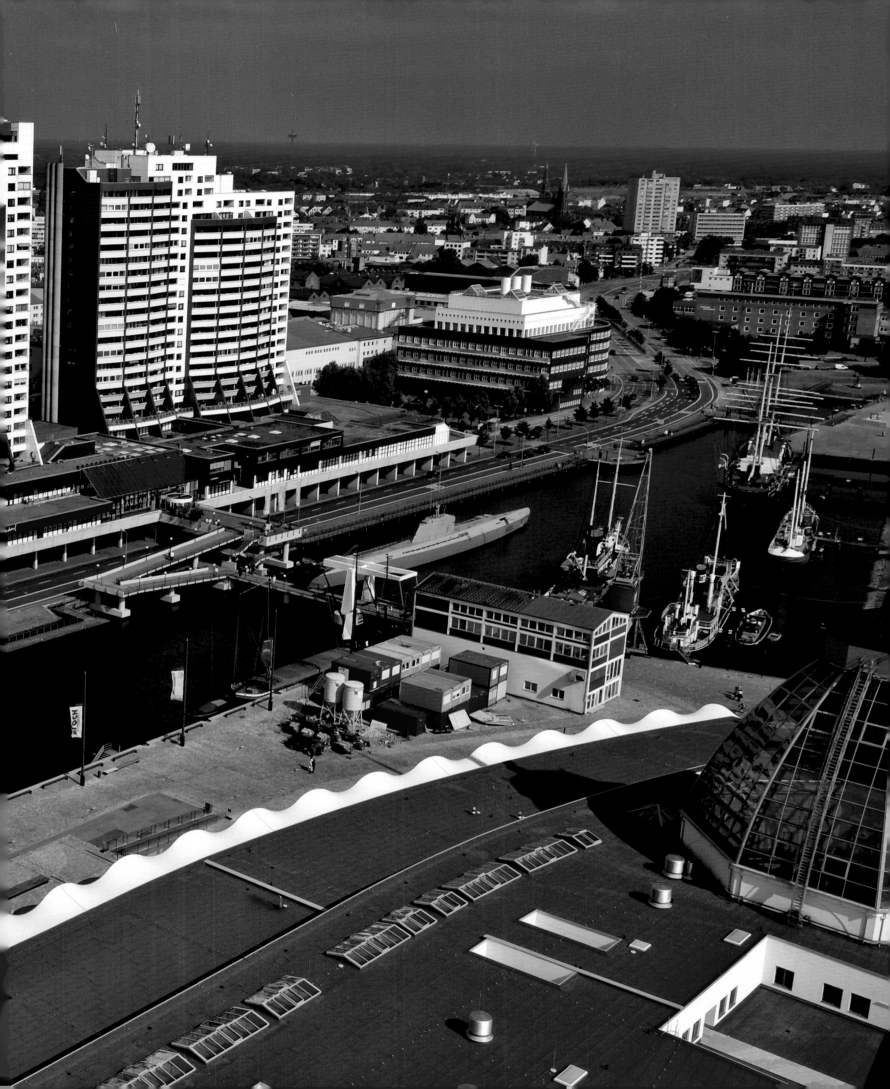

Bremen – a village with trams

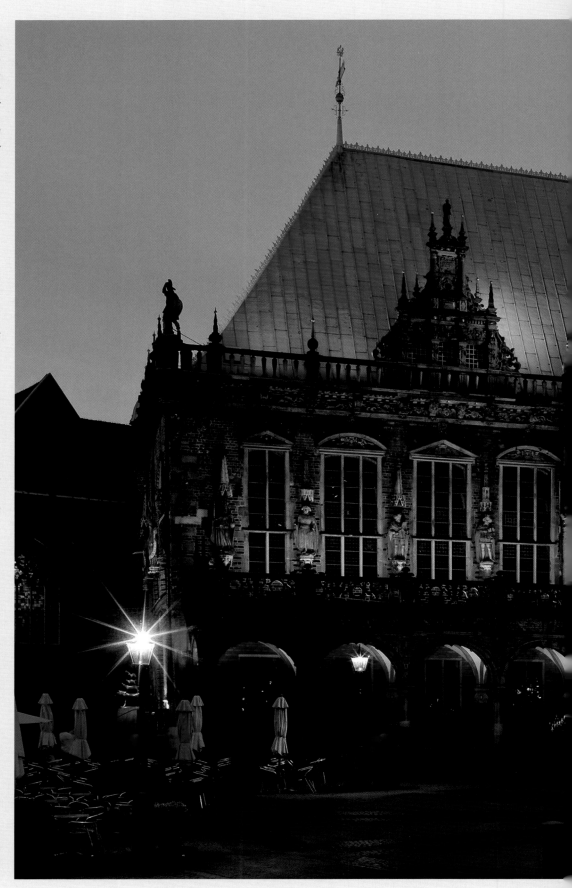

After the statue of the Bremen Town Band the town hall is one of the most popular photographic motifs in town. It was built as a Gothic hall between 1405 and 1410 and refurbished in Weser Renaissance by Lüder von Bentheim in 1608–1612. This was when it was given its present façade.

Bremen and its people – now there's a strange relationship. On the one hand the locals constantly moan about what's wrong with the city; on the other they just wouldn't be without its unique atmosphere. Bremen is perhaps one of the most successful symbioses of village plus metropolis – firstly, because everybody knows everybody else and secondly, because the distances between A and B are very short. It thus comes as no surprise that somebody somewhere once came up with a paradox as a nickname: "Bremen, the village with trams". And in the 'village' life is played out in the various quarters and suburbs. About ten years ago one Hamburg professor remarked that he knew of no other city in Germany where more people were as attached to their particular part of town as in Bremen.

The city of Bremen is not somewhere that defines itself by the merits of its weekly market, shooting matches and voluntary fire brigade. For hundreds of years life here has been shaped by trade and change. Bremen was one of the pioneers of globalisation, with its merchants establishing contacts all over the world very early on. Business relations stretched as far as China, Australia and South America, for many centuries providing the Hanseatic city with its livelihood. It's thus no wonder that Bremen has kept its sense of cosmopolitanism – and will undoubtedly continue to do so.

The motto of the people of Bremen is written above the entrance of the Schütting, the headquarters of the chamber of commerce and guild of merchants. "Buten un binnen – wagen un winnen", roughly translated as "Outside and in – venture and win", encapsulates that which has made Bremen what it is down the centuries: its striving for independence under the auspices of the Hanseatic League, that legendary medieval union of cities whose network covered the whole of Europe.

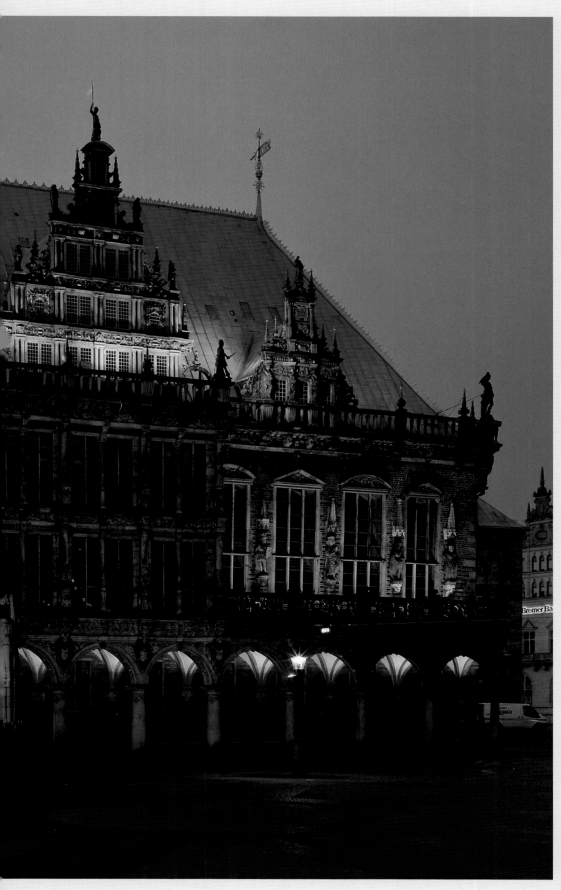

City history

The history of Bremen is excellently presented at the Focke Museum. The first settlements on the River Weser were founded between the 1st and 8th centuries AD. Early townsfolk found that the Bremen dune offered them perfect protection from flooding. There was also a ford where they could cross the river. On the site of what is now the cathedral the dune was about ten metres (33 feet) high, dropping three to four metres (ten to thirteen feet) down to the Balge, a sidearm of the Weser that existed until into the 19th century, where a ferry was operated.

Then came the missionaries. In c. 780 Emperor Charlemagne sent Saint Willehad up into the wild north. It is to him that the later town owes its first (infamous) mention; in 782 the crusader and his followers were hounded out of the settlement and two of his priests struck dead, writes Willehad. It took another five years for the men of God to convert the heathens and Bremen to be made a diocesan town. Initially under the rule of the archbishop of Cologne, in 848 the Normans plundered Hamburg, prompting Archbishop Ansgar to move his seat of office from the Elbe to the Weser in 848/849. The first cathedral was erected on the dune in wood – and destroyed by the Vikings. Ansgar then had a more permanent structure built in stone. This was fortified with walls, ditches and gateways. In 1032 the first city walls were constructed. For many centuries the cathedral chapter was an enclosed, autonomous area. More and more people came to Bremen, however, and settled between the cathedral and the River Balge. The river surrounded the settlement and functioned as a natural harbour largely serving the East Frisians. They came up the Weser on their sea-faring vessels to trade. On August 10, 965, Emperor Otto I thus granted the city the right to hold markets, mint coins and levy tolls.

In the decades and centuries that followed the history of Bremen was turbulent. Even tucked away on the Lower Weser, Bremen had its fair share of war and disease. Despite this the city constantly strived to increase its power and standing, joining the Hanseatic League in 1260. However, Bremen didn't always prove a good ally and was almost thrown out on several occasions.

Support from the Hansas

This would have undoubtedly been an absolute catastrophe, causing the city to develop quite differently than it was to in the coming centuries. With support from the Hansas the citizens grew ever more confident in their opposition to their

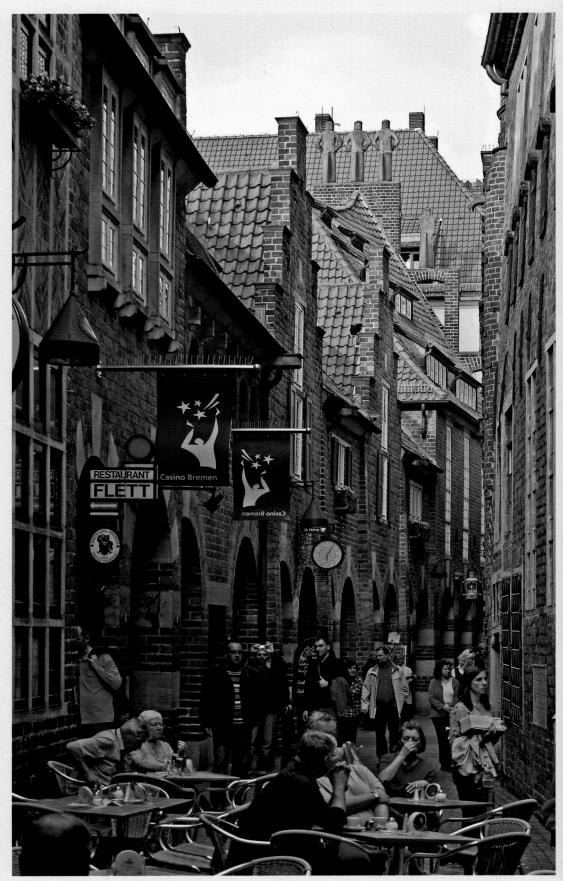

ecclesiastical potentates. As a symbol of their freedom they erected the stone statue of Roland in 1404 and five years later the Rathaus or town hall, both of which are now UNESCO World Heritage Sites.

Bremen joined the Hanseatic League chiefly because it wanted to trade – and because its fleet was constantly being threatened by pirates. The harbours always were the Achilles heel of the city. In the early Middle Ages the ships docked on the Balge – until the Schlachte on the banks of the Weser was given the honour. Until the second half of the 19th century Bremen then did battle with the Weser which was forever silting up with sand. Sea-faring vessels had to be unloaded further and further downstream. A harbour was subsequently built about 30 kilometres (18 miles) out of town in Vegesack, the oldest man-made port in Germany. Yet in 1827 the city was again faced with the sedimentation of the River Weser.

Bremen then procured a strip of land from Prussia north of the little River Geeste, laying out both a seaport and the town of Bremerhaven. Up until 1945 the Weser Estuary changed municipalities several times; only the ports remained firmly in the hands of Bremen City. The senate had made sure of this well in advance, creating an administrative oddity that is unique worldwide; in the two-enclave state of Bremen the harbours have always belonged to Bremen's city council.

The Hanseatic city now had a hold in the marine waters of the Outer Weser yet the senate was still not happy with the state of the river. In 1884 a new future dawned for the historic centre of trade when hydraulic engineer Ludwig Franzius straightened the Weser and had it deepened. This meant, however, that the Schlachte could no longer be used as a harbour. The senate thus acquired the Stephanikirchweide and had Bremen's first new harbour built: an international port later entitled Freihafen II. This sparked off a wave of industrialisation in both the city and entire region that was exem-

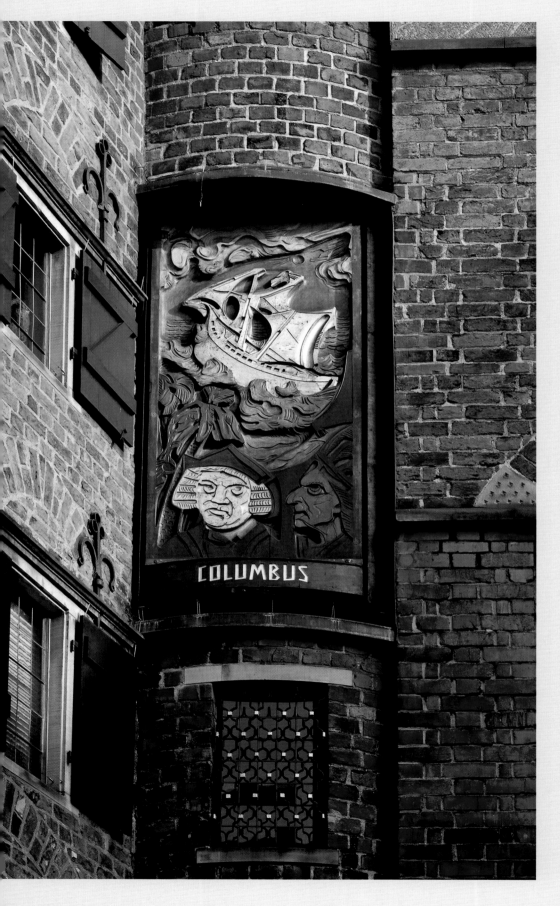

COLUMBUS

plary. The harbours have received preferential treatment for over 100 years now and shaped the way the people of Bremen think and act. During the 19th century Bremen was also where Emperor Wilhelm II indulged his bold visions of colonialism. In the 1880s the German Empire had begun building up its territories overseas, an undertaking in which many Bremen businessmen, including one Adolf Lüderitz, played a large part. Bremen's overseas museum and the colonial monument not far from Bürgerweide still bear witness to the city's colonial past.

Since the end of the 1990s a lot more has been going on in the harbours. The international port has been filled in; new life is currently being breathed into the quarter of Überseestadt which is taking its place. Many creative minds are helping to reinvigorate these old parts of town and to bring the city closer to the waterfront than it has been in the past few years.

Making a lot out of nothing

And then there's Bremen and money. The community may be practically broke but Bremen has a second financial string to its bow in its sophisticated system of patronage. Not many people know that Bremen has more foundations and endowments than any other city in Germany. And if it's millionaires you're looking for, you don't have to go much further than the Weser.

Patronage of the arts goes back to the 19th century. Those who were part of the up-and-coming middle classes did well to give money to charity. The more the benefactor did so, the greater his or her reputation and influence. This didn't go unnoticed by the city's art aficionados and soon Bremen had an early system of fundraising up and running. Not much has since changed. The Kunsthalle or art gallery, for example, is still generously supported now as it was then by people with large bank accounts. They are all members of the Kunstverein or art society, both the proprietor and body in charge of the Kunsthalle.

It may seem hard to believe but Bremen still actually has a knight's castle! Schloss Blomendal is named after the northernmost suburb of Bremen, Blumenthal, where it is situated. It was built in c. 1354 and was first used as an administrative seat in the 16th century. It now houses a kindergarten and a small museum.

Two more examples of Bremen patronage are the Schaffermahlzeit and the Eiswette. The first has been proved to be the oldest charity ball in the world. Since 1545 Bremen merchants, shipowners and captains have taken part in the feast, the proceeds of which go to Haus Seefahrt, an institution for the welfare of former sea captains and their wives. Three businessmen and six mariners invite guests to the gala dinner. The former have to pay for the banquet which has been held in the Obere Rathaushalle since 1952; the latter are 'allowed' to donate money to Haus Seefahrt. The procedure is pretty informal; the relevant sum can be scribbled on the back of a business card. The Schaffermahlzeit is a star event with many prominent faces; in 2009 German president Horst Köhler attended and in 2007 German chancellor Angela Merkel – although strictly speaking no women are usually allowed.

Where the Schaffermahlzeit takes place in select circles, the Eiswette is a very public form of entertainment. When the clock strikes twelve noon on Epiphany the city's 'bachelors' congregate on Punkendeich on the Weser to bet whether the Weser is frozen solid or not. As they first did in 1829, they test their theories by sending a 99-pound tailor with a hot iron across the Weser. If he keeps his feet dry, the prize is Braunkohl – cabbage with all the trimmings – served at the Eiswette banquet. Guests to the event donate money to the DGzRS or the German Maritime Search and Rescue Service.

We have liftoff!

Since the beginning of the 20th century Bremen has also been a major centre of the German and later European aviation industry. One undisputed pioneer was Henrich Focke who was obsessed by the idea of building better and better aircraft. Before the First World War Henrich and his brother Wilhelm were testing their model planes on the Osterdeich. In 1908 the inventor began studying mechanical engineering in Hannover and with Georg Wulf founded the Focke-Wulf-Werke in Bremen, from which he was later ousted by the Nazis.

In the 1960s the company was merged to form the Vereinigte Flugtechnische Werke or VFW. The united aeronautical works didn't prove very successful economically but it did lay the foundations for Bremen becoming one of the top venues for international aerospace. At the beginning of the 1970s VFW subsidiary ERNO thus managed to snatch the contract for Germany's Spacelab right out from under the noses of Bavarian competitor Messerschmidt-Bölkow-Blohm.

This prowess in the field of aviation has continued to put Bremen on the map. Without Bremen none of Europe's Ariane rockets would ever have left the ground, for example. EADS subsidiary Astrium is namely responsible for the manufacture of the upper stages of the Ariane 5. The aerospace industry holds such great significance here that two local high schools even offer suitable study profiles: one in the north and the other in the south of the city.

Famous people, great minds

Bremen has been home to many famous people who have made a lasting contribution to the social, economic and political development of our planet. In the 19th century especially the world had various great minds born in or connected with Bremen to thank for a number of important discoveries. One of these trailblazers was African scholar Gerhard Rohlfs. His travels provided his contemporaries with valuable facts on a part of the world about which very little was known until well into the 19th century. Its interior in particular was literally foreign terrain until Rohlfs became one of the first Europeans to cross the Sahara.

One of the artists of Worpswede who pointed art in a totally new direction with his oeuvre was Fritz Overbeck. He was fascinated by the scenery surrounding the moorland village near Bremen and set up a studio on Weyerberg in 1896. A year later he married his student Hermine Rothe and in 1905 moved with her to the north of Bremen. Just four years later Overbeck died there. His contemporaries include Johann Heinrich Vogeler, Bernhard Hoetger and Rainer Maria Rilke, all of them also active in Worpswede. Vogeler is particularly famous for his Jugendstil works.

One of the best-known German designers of household objects was Wilhelm Wagenfeld, born in Bremen in 1900. He did an apprenticeship at the equally famous Bremen silversmith's Koch & Bergfeld and at the beginning of the 1920s joined the Bauhaus in Weimar as a silversmith. Here, among other commodities, the basic prototype of the Wagenfeld table lamp was created. During the Third Reich Wagenfeld

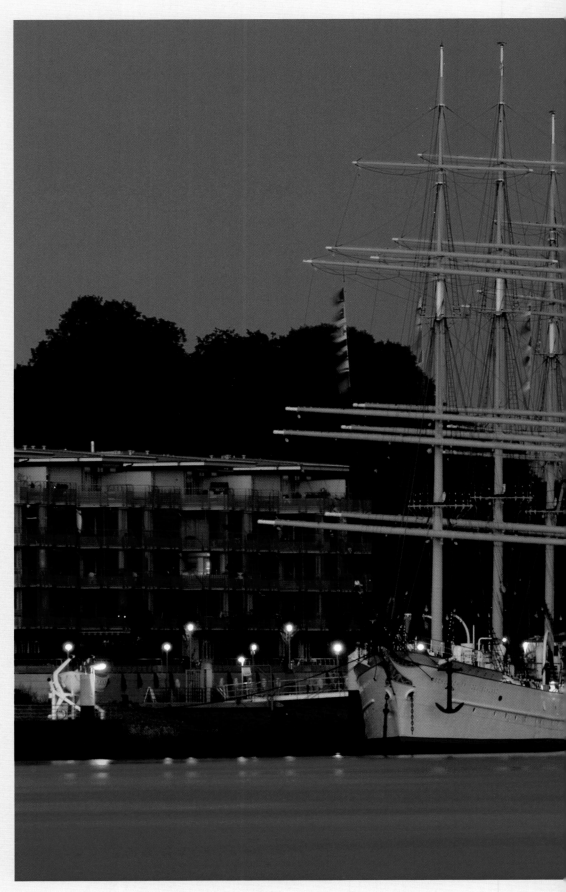

occupied an exposed post at his place of work but refused to join the Nazi Party. He was thus sent to the Eastern Front. In Germany he later worked as a designer for large companies such as Braun, WMF and Rosenthal.

Something else Bremen is famous for is coffee. During the years of the Wirtschaftswunder or economic miracle Jacobs Kaffee became one of Germany's most successful consumer products. Jacobs also promoted horseracing and even ran a stud farm, the Gestüt Fährhof.

Those with a sensitive stomach also have a lot to thank Bremen for – or rather one Ludwig Roselius. The businessman wasn't just a keen patron of the arts; he also invented decaffeinated coffee. He had his innovation patented and in 1906 founded the Kaffee-Handels-Aktien-Gesellschaft or Café HAG, to give it its modern spelling. He made millions. Later Roselius came up with Kaba, an instant chocolate drink, and Onko coffee, both still sold in Germany. Despite his merits in the art world Roselius is something of a problematic figure. He was a member of the Akademie für Deutsches Recht, the Nazi institution entrusted with the rewriting of German law, and a supportive member of the SS. For several decades Bremen was also famous for three letters: EWG. These stood for Einer wird gewinnen (One will win) and were the title of a game show on ARD hosted by Bremen native Hans-Joachim Kulenkampff. His programme featured eight candidates from all member states of what was then the European Community and attracted millions of viewers. Born in 1921, Kulenkampff was a son of the sea and loved sailing, even though he made a new home for himself in Austria.

Another Bremer, Hans Koschnick, was a great mediator and in the 1990s became synonymous with the Balkan peace process. Up until 1985 he was mayor of Bremen, then a member of parliament from 1987 to 1994 before becoming administrator for the European Union in Mostar for two years after that. In this role Koschnick survived two terrorist attacks. He also earned himself worldwide recognition as the holder of many honorary offices. Koschnick turned 80 in 2009.

No less famous than Hans Koschnick, at least among the younger generation, is Jürgen Trittin. The former German minister for the environment and member of the German Green Party was born in Bremen and did his Abitur or A levels here. He later moved to Göttingen where he graduated in social economics. Trittin's great achievements include negotiating the German government's abandonment of nuclear energy.

The Bremen Town Band

There is hardly a child in Europe who isn't familiar with the story of The Bremen Town Band. Written down by the Brothers Grimm in the 19th century, it is one of the most famous fairytales to come out of Germany. The tale goes that a donkey, dog, cat and cockerel no longer able to serve their masters set off for Bremen to become musicians. According to the Brothers Grimm, they never reached the city and instead had to drive a band of robbers from their house in the woods. This is said to have happened near Kirchlinteln or Syke; the two communities and various scholars are still in dispute about it.

What is a given fact, however, is that the people of Bremen love their musical animals to this very day. And especially Gerhard Marcks' statue of them from 1953, tucked away next to the Rathaus. Concern that visitors to the city won't find Donkey, Dog, Cat and Cock is groundless; as if they have a sixth sense, guests automatically wander from the statue of Roland to the likeness of the four famous beasts. A 'sacred' rite is then performed, in which boys and girls, men and women of all nationalities have their photo taken with their furry and feathered friends – with some very enthusiastic followers even giving the bronze figures an affectionate cuddle.

Bremen and Bremerhaven

Bremen and Bremerhaven are like a doomed couple; fatefully locked in a love-hate relationship, they can't be together and can't be apart. Whether they like it or not, Bremen and Bremerhaven are a unit and will always remain so – unless in the distant future the federal state of Bremen should ever be dissolved.

In the beginning, when the state was born, their love for one another was great. For years the debate raged as to whether Bremerhaven should become part of the British zone with Geestemünde and thus be assimilated by the federal state of Lower Saxony or stay in the American enclave of Bremen. Thanks to the craftiness of the Bremen negotiators under Mayor Wilhelm Kaisen and a clear vote from

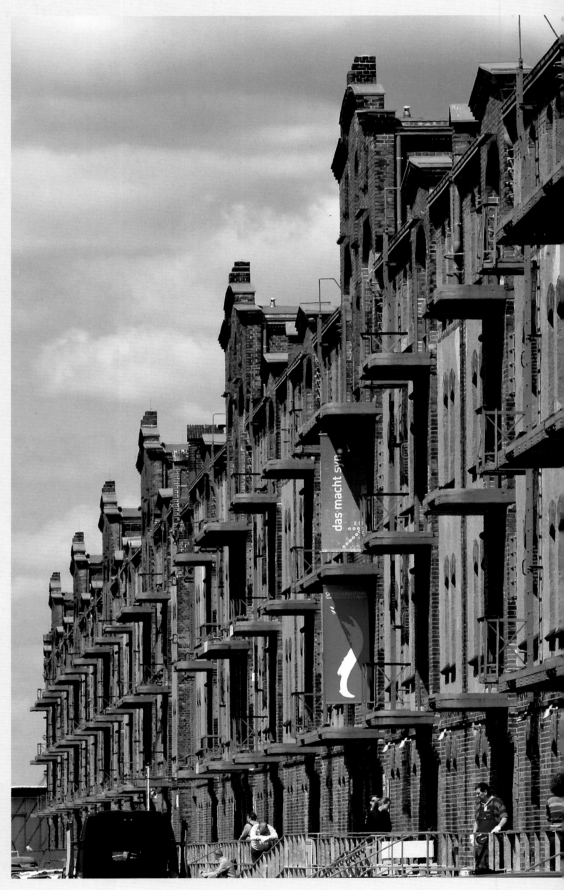

the mouth of the Weser the two-city state exists now as it did then – complete with all of its quirks and idiosyncrasies.

There are three legal anomalies here. Firstly, the sea and international ports belong to the city of Bremen because the local authorities don't want to miss out on the taxes these generate. Secondly, Bremerhaven is a free city – in other words, it can do as it pleases. There is some form of loose administration on the Bremen side but this is merely treated as a recommendation. Thirdly, there is the issue of the Bremen voting system. A political party or association of voters can take up seats in the Landtag or state/city parliament if they gain the stipulated five percent of the vote in Bremen or Bremerhaven. In writing it, the authors of this law tried to even out the disadvantages Bremerhaven has in relation to Bremen.

Despite this and various other tokens of love proffered by Bremen, the burghers of Bremerhaven have looked downstream with growing mistrust over the years. The view throughout all strata of society upriver is that the people of Bremen are far too arrogant in their treatment of their little sister. The Bremerhavener would like to see more understanding shown towards their needs and concerns.

The face of Bremen

Almost seventy years ago Bremen lost face – literally. In World War II Allied air raids destroyed over sixty percent of the city. With its shipyards and aviation companies Bremen was a hub of the German arms industry, making it a clear target. The bombs annihilated much of the ancient fabric of the city; the historic centre has since been completely rebuilt. Only the site where the stock exchange once stood now features a 1960s edifice, the Haus der Bürgerschaft and seat of state parliament.

The heart of town is made up by the town hall, the statue of Roland and the Weser embankment. Where Bremen is absolutely unique is in the various suburbs, where row upon row of tiny houses huddle together as if for warmth and comfort. The town villas and palatial residences in Oberneuland, Borgfeld, Lesum and

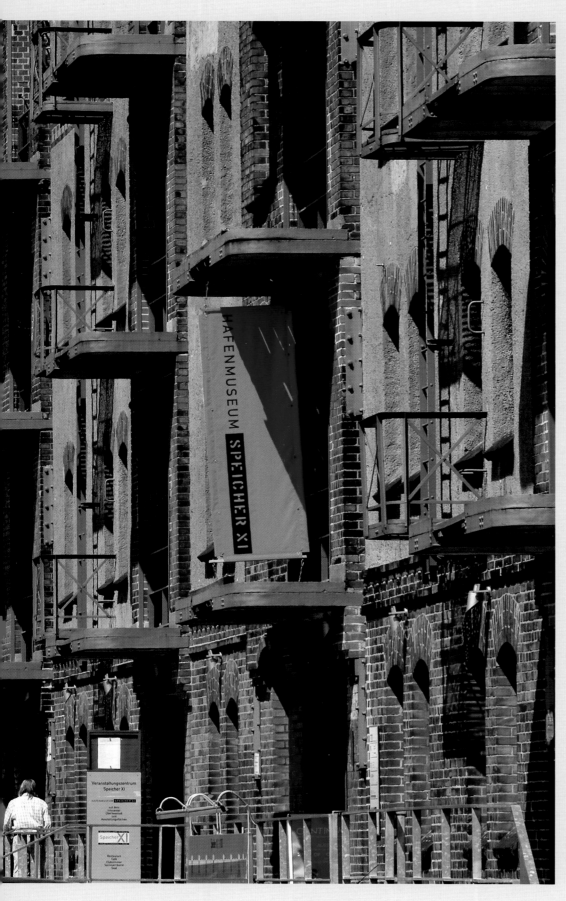

St Magnus are more generously proportioned. Bremen, the old Hanseatic port, has plenty to offer, from the architectural gems of the Gründerzeit to the modern constructions of the post-industrial age.

Bremen is also very green. There's the Bürgerpark laid out by Wilhelm Benque, for instance. And the rhododendron park and botanical gardens attract people from all over Germany every year to the city where they come to admire the many varieties of this magical bush planted here. In a more simplified form there are also plenty of natural havens in the suburbs; Höpkens' Ruh, Grünzug West, Stadtgarten Vegesack and Oberneulander Park are just some of the places where the locals like to go out for a gentle stroll "once round the pudding", as they say here.

When it comes down to it, the small city of Bremen, with its short distances of travel, really is just a village – albeit one with a set of trams. Fields, meadows and forest are as close as the urban jungle with all that comes with it – from art and leisure to business and shopping.

Page 22/23:
Bremen, the city on the River Weser, seen from above. Its green belt, the former defences that fortified the old town until the 17th century, is clearly discernible. Bremen's cathedral is also visible, characterised by its twin spires erected in the 19th century.

Page 24/25:
Sunset in the Breites Wasser nature reserve near Worpswede. This play of light and colour in idyllic surroundings once inspired artists such as Heinrich Vogeler, Rainer Maria Rilke and Bernhard Hoetger to set up an artists' colony in the middle of Teufelsmoor.

21

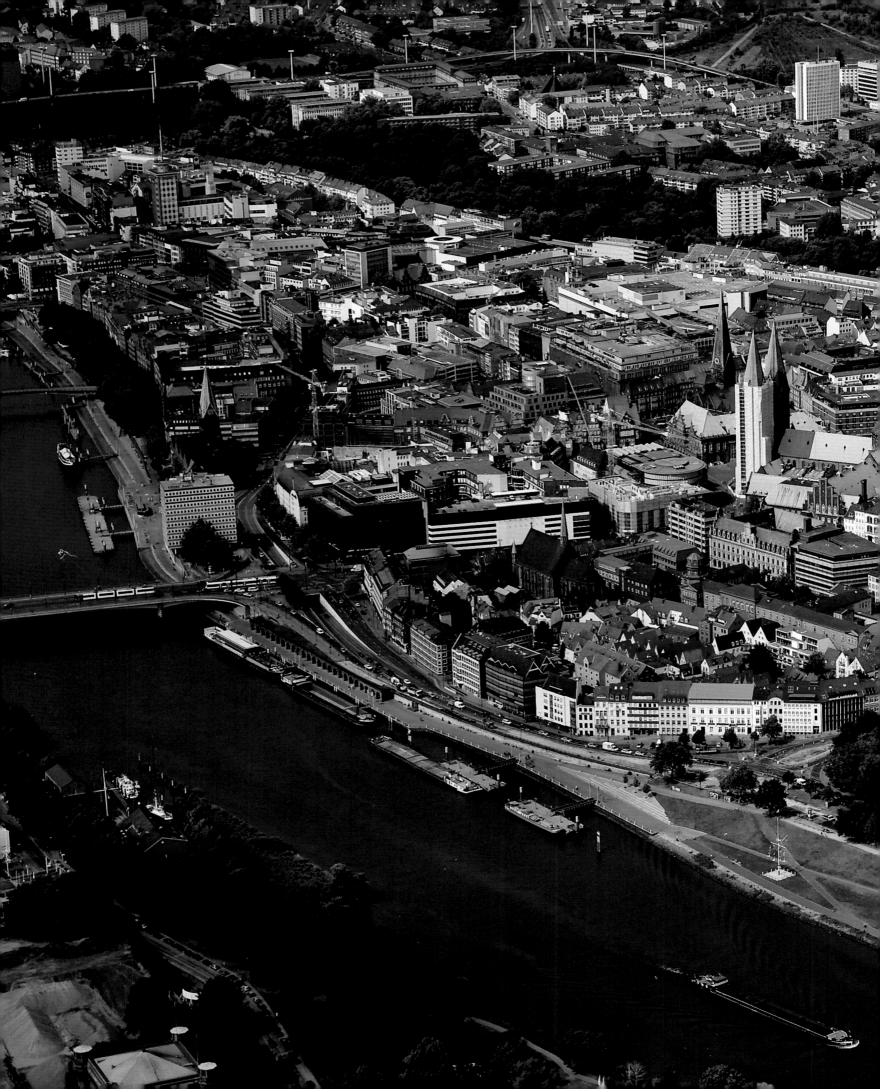

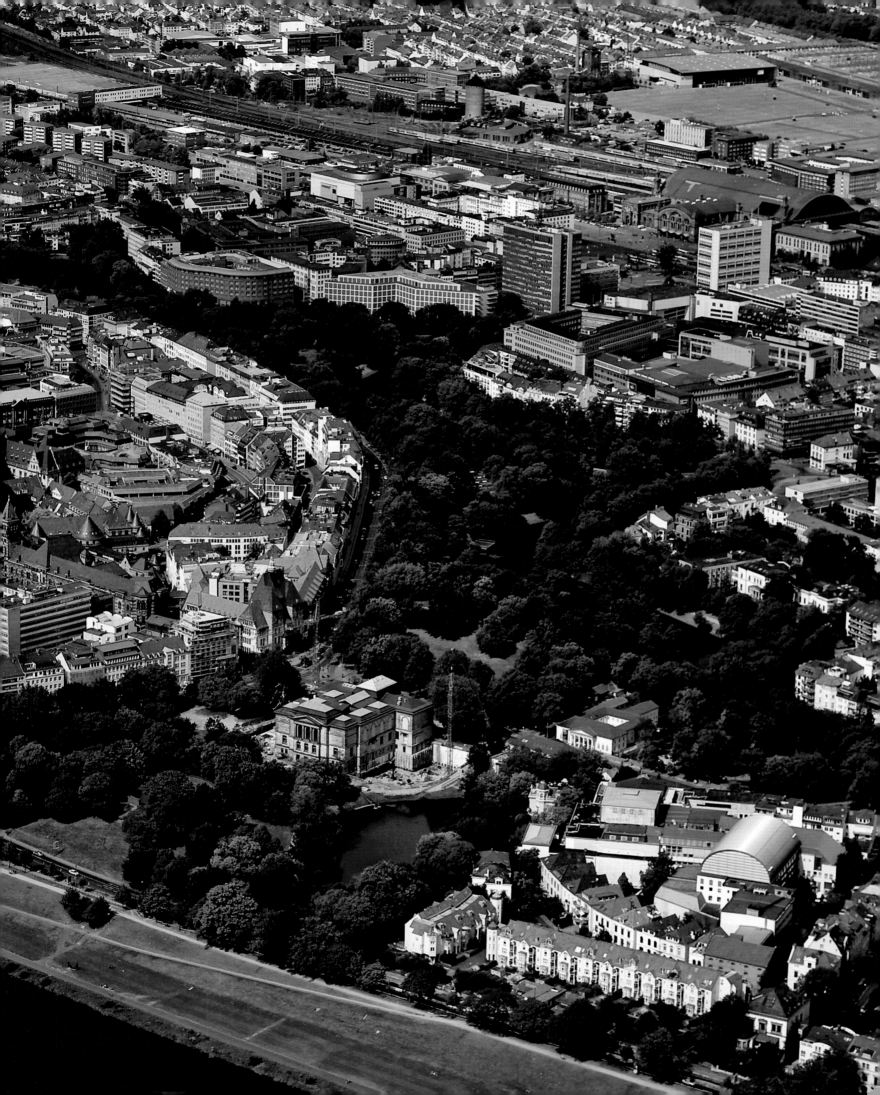

From the marketplace to the Weser – the city centre

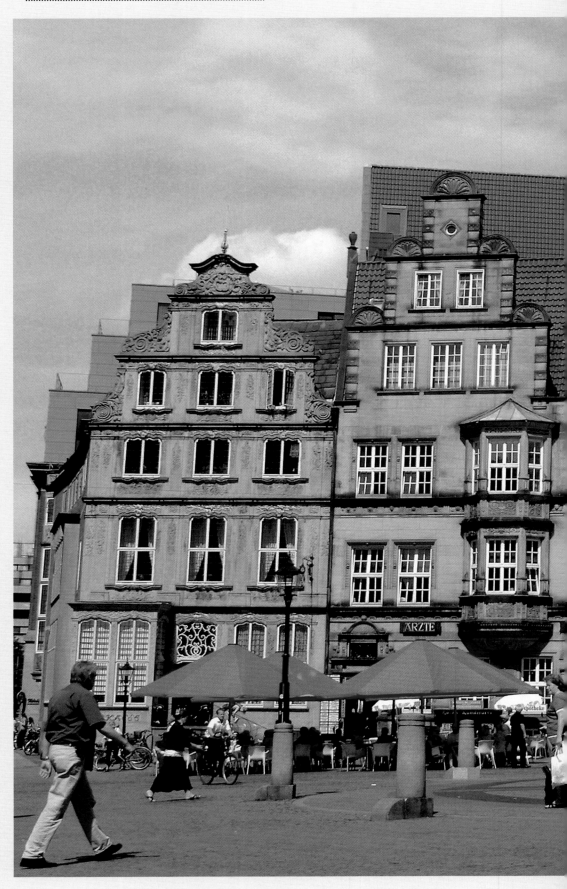

The northwest side of the marketplace in Bremen is lined with gabled houses built in the 16th century. Perhaps the most famous is the house on Markt 11 from 1594 (left). In 1830 it was given a Biedermeier façade and in 1893 the top floor burned down, causing architect Max Salzmann to design a new centre gable for the building.

Bremen is rediscovering its river. For decades it was as if Bremen and the Weser simply existed in parallel. Then in the 1990s something happened: the city began its return to the waterfront – much to the joy of the people who live here. This process is now in full swing, with many new exciting elements being added to what's already there.

The heart of the city still beats at its centre with its marketplace, 600-year-old statue of Roland, Rathaus and weekly fruit, vegetable and flower market. The citizens of Bremen treat Marktplatz as their very own municipal parlour – and do their utmost to keep it looking spick-and-span. The same applies to Roland, the symbol of a confident town populace. He and the town hall are now both UNESCO World Heritage Sites.

From here it's just a short walk to the Schnoor, Ostertor and Steintor. The Schnoor is the oldest quarter in town and full of top-class pubs and restaurants, upmarket crafts outlets and goldsmiths, a glass blower's, antiques shops and little museums. Ostertor and Steintor are heralded as the trendiest parts of town.

From the centre it's not far to the old town defences. This is where Bremen's city walls once stood; now a park, they take visitors beyond the station into the Bürgerpark. The latter, designed by Wilhelm Benque over 140 years ago, is an oasis of green in the middle of the Hanseatic city.

Over the past ten years the Weser embankment or the Schlachte has become a popular place to hang out. Its pubs, bars and restaurants are a hot favourite with visitors, especially in the summer.

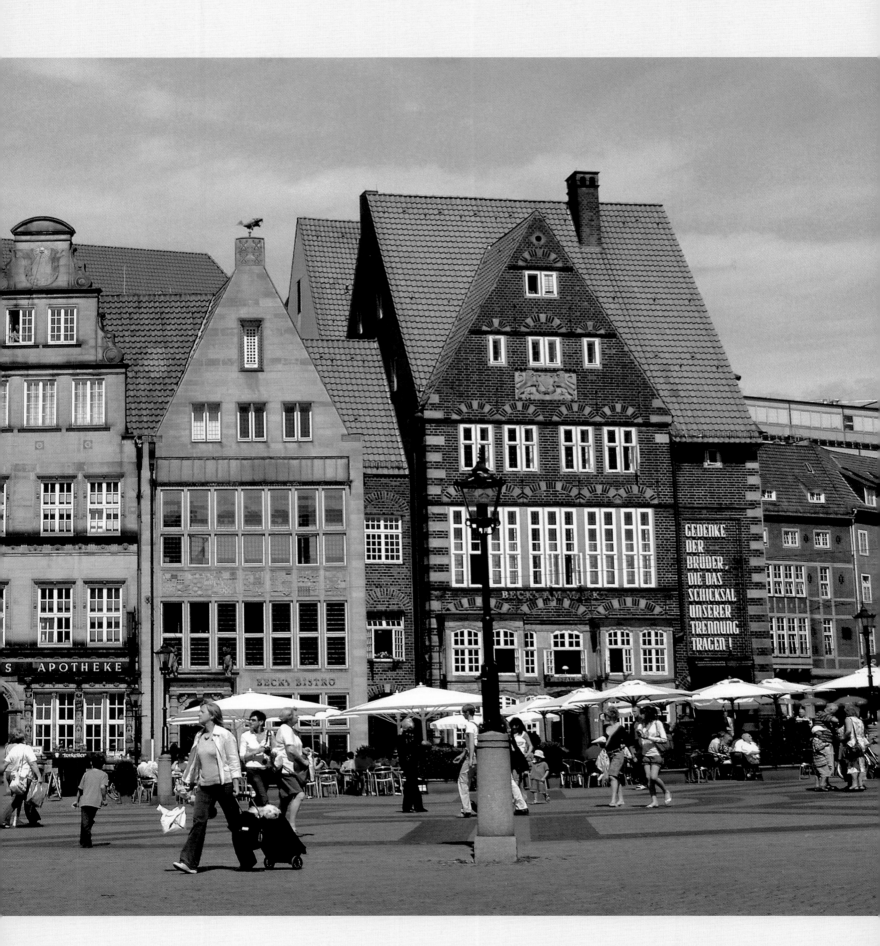

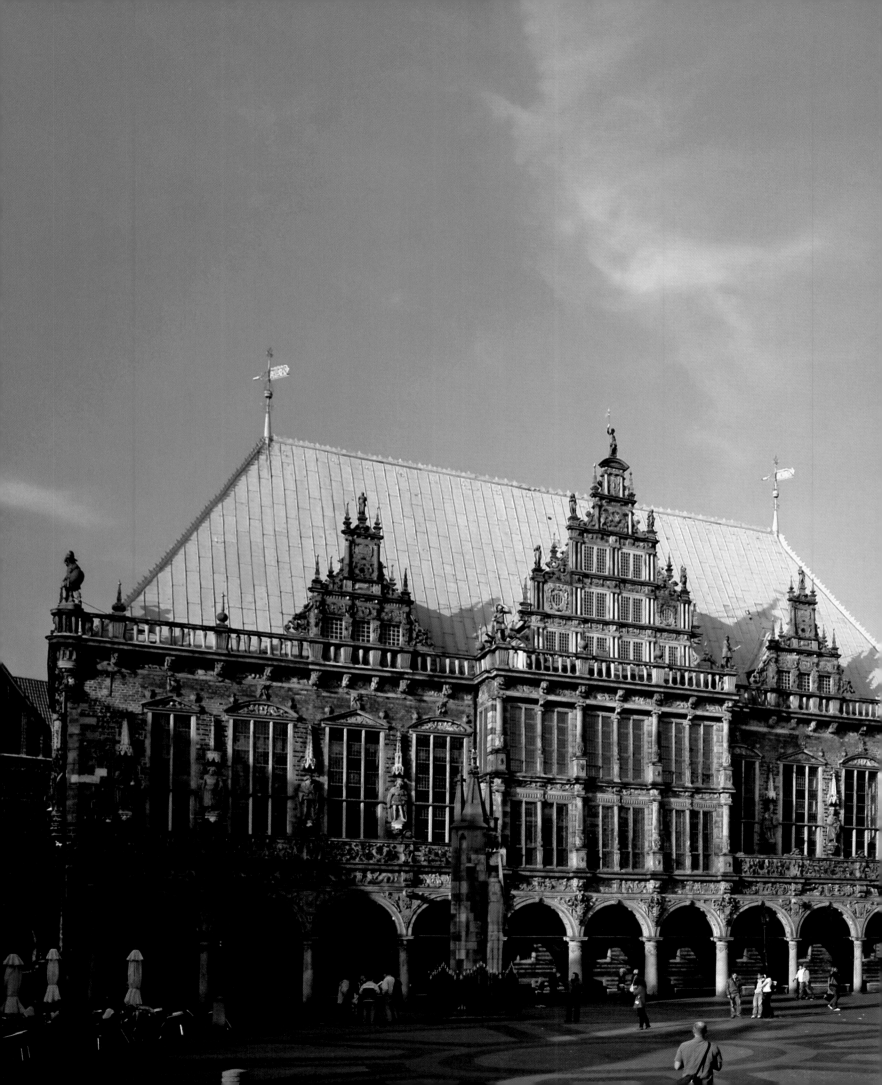

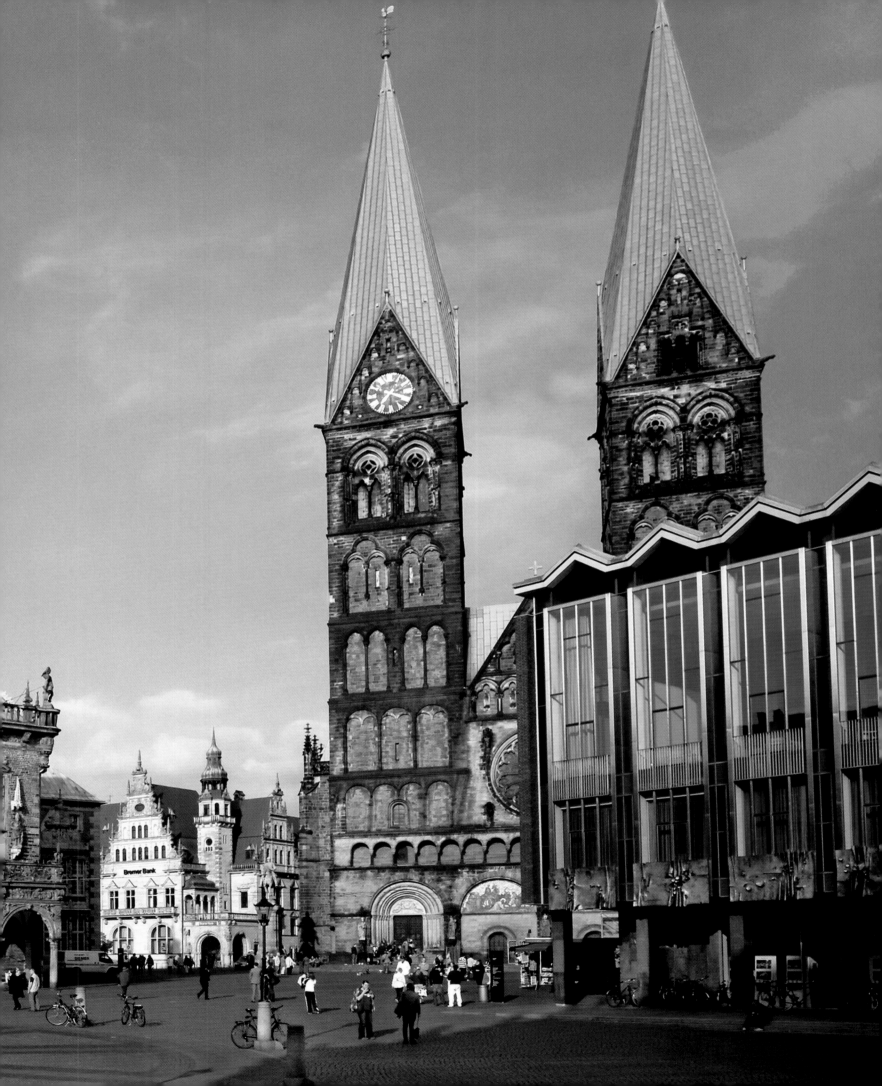

Page 28/29:
The marketplace with the town hall, cathedral and Haus der Bürgerschaft is Bremen's showpiece. The latter – the seat of state parliament – stands on the site of what was the magnificent neo-Gothic stock exchange.

The Obere Rathaushalle is the most famous room in Bremen's seat of government. Once reserved for the exclusive use of the city's top officials, it's now the venue for a great number of events. These range from acts of state to the popular Nacht der Jugend for the city's younger generation. The Obere Rathaushalle took on its present Gothic form when the town hall was rebuilt between 1608 and 1612.

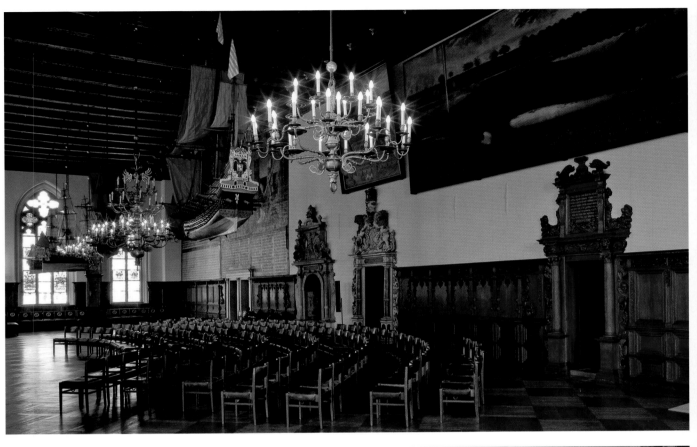

Barrel of wine with Bacchus astride it in the Ratskeller in Bremen. The cellar was built in 1405 together with the town hall. It is the oldest wine cellar in Germany and with 650 different varieties Bremen has the largest assortment of German wine in the world. The Bacchus cellar was built in 1847 as an extension of the great hall.

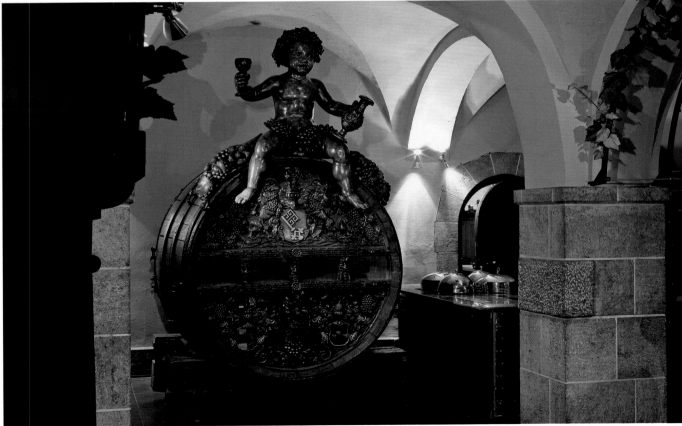

Right page:
This winding staircase was put in when the Rathaus was rebuilt in the 17th century. It leads from the lower to the upper Güldenkammer or golden chamber and is extremely rich in its ornamentation.

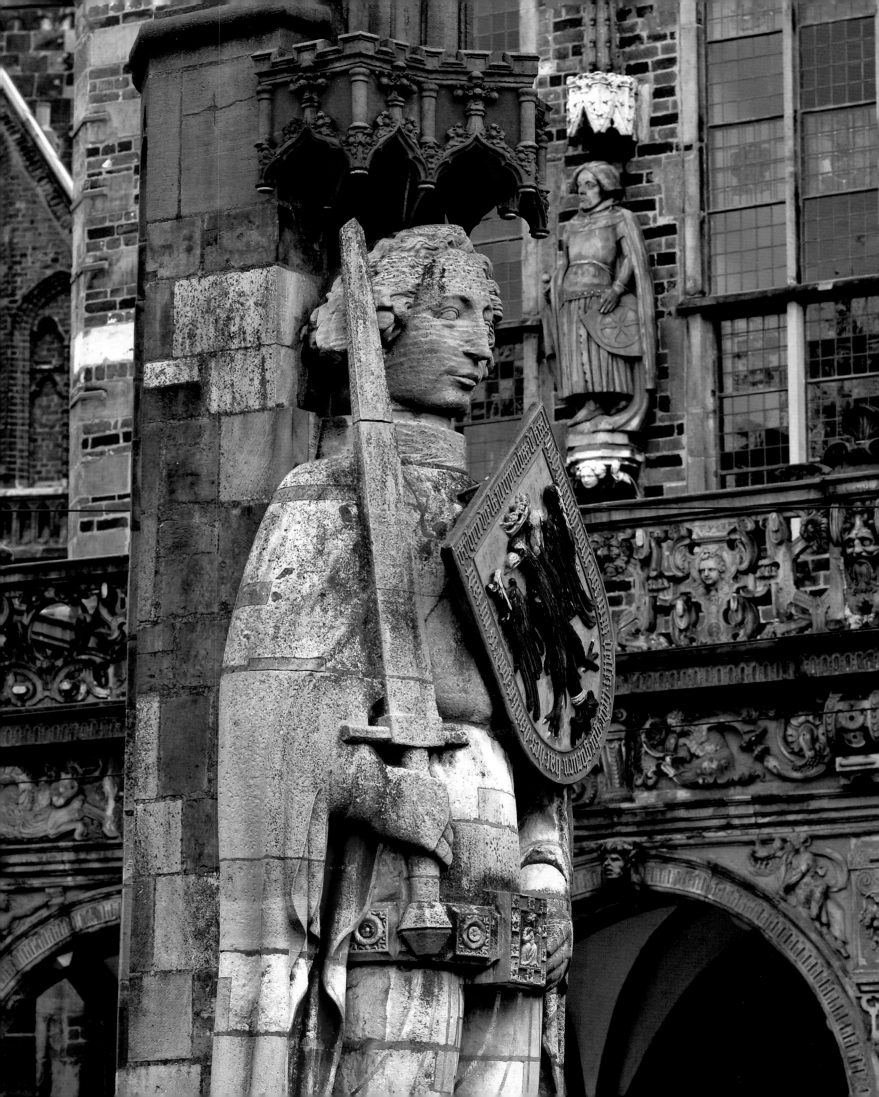

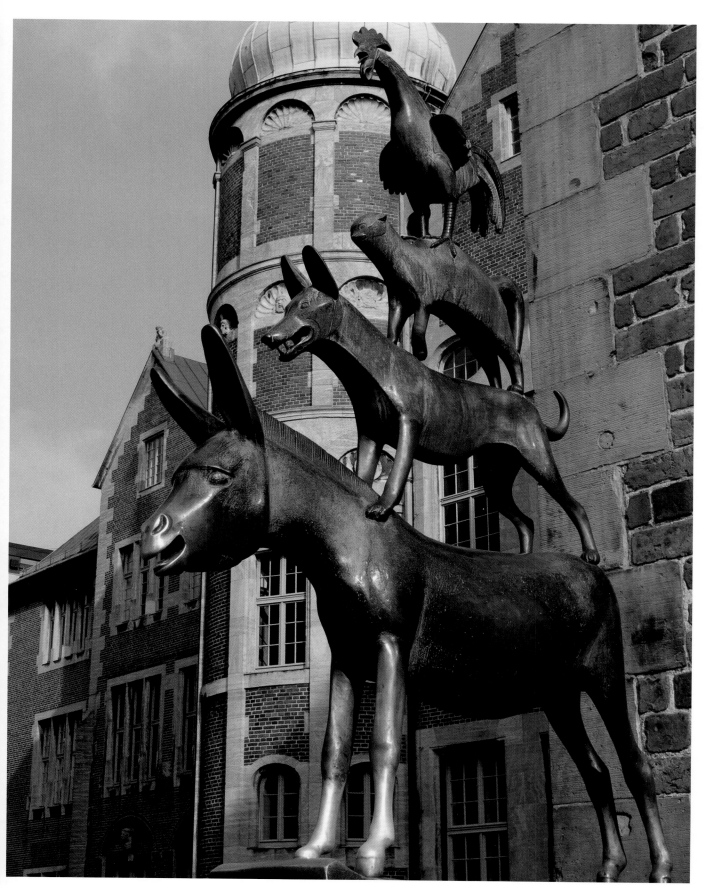

The statue of Roland, erected in 1404 and together with the Rathaus made a UNESCO World Heritage Site in 2004, is a popular meeting place for the people of Bremen and visitors to the city. Roland is 5.47 m / 17.9 ft tall and stands on a base 60 cm / 23" high. With his supporting pillar and crowning ciborium, Roland measures exactly 10.21 m / 33.5 ft. He was given the right to bear the imperial coat of arms on his shield after the people of Bremen wilily forged certain historical documents ...

Grimms' fairytale of the Bremen Town Band is famous the world over. The donkey, dog, cat and cockerel probably never actually reached Bremen. This didn't stop sculptor Gerhard Marcks erecting this affectionate statue to them in 1953.

Right:
Schütting on the corner of Marktplatz/Böttcherstraße is the headquarters of the chamber of commerce and guild of merchants. The house was built in 1537/1538 yet its front was changed several times. In 1818, for instance, the entrance on the left was replaced by the portal we still see today.

Far right:
The gabled houses where rich families once lived decorate the north end of the marketplace in Bremen. Here, one of the ornate windows.

Right:
While the gentlemen of Bremen held session upstairs, the people could shelter down below. The arcades beneath the Rathaus were added when it was redesigned in the 17ᵗʰ century. One section threatened to collapse in the 1960s after a tram crashed into it.

Far right:
Abstract reliefs by Bernhard Heiliger embellish the main entrance to the Haus der Bürgerschaft. The motifs belong somewhere between the exploration of the cosmos and the study of nature. When Heiliger was commissioned by the building's architect, Wassili Luckard, to make the designs, he was still unknown.

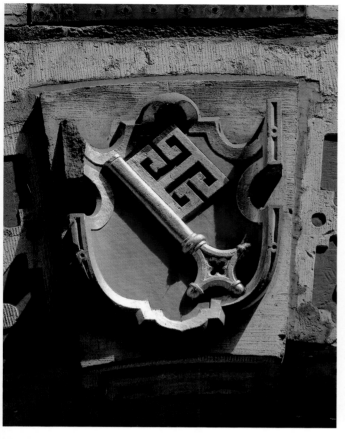

Far left:
The Bremen coat of arms decorates the entrance to the city weigh house on Langenstraße. The free Hanseatic city of Bremen has a key on its small, medium-sized and large shield, the present form of which was stipulated in 1891.

Left:
We can work out where Roland came from by looking at his belt buckle. According to the saga Roland was a Breton paladin and the nephew of Emperor Charlemagne. The angel indicates that he was also a martyr.

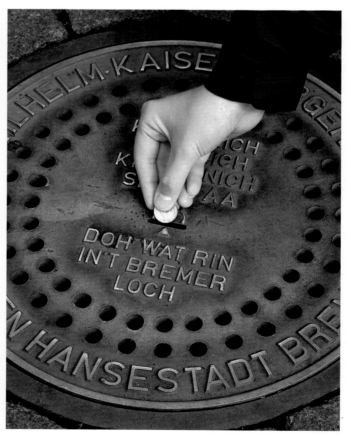

Far left:
This town hall arcade tells the tale of the lucky hen of Bremen. Legend has it that during a terrible storm fishermen on the Weser espied a mother hen and her chicks perched out of the water on a sand dune, guiding them to safety. This also allegedly led to the founding of the city of Bremen.

Left:
In 2007 this donations box for the Wilhelm Kaisen citizens' aid group was set into the pavement outside the Haus der Bürgerschaft. Known as the Bremer Loch (hole of Bremen), those who put one euro in the slit are rewarded by the dulcet tones of the Bremen Town Band.

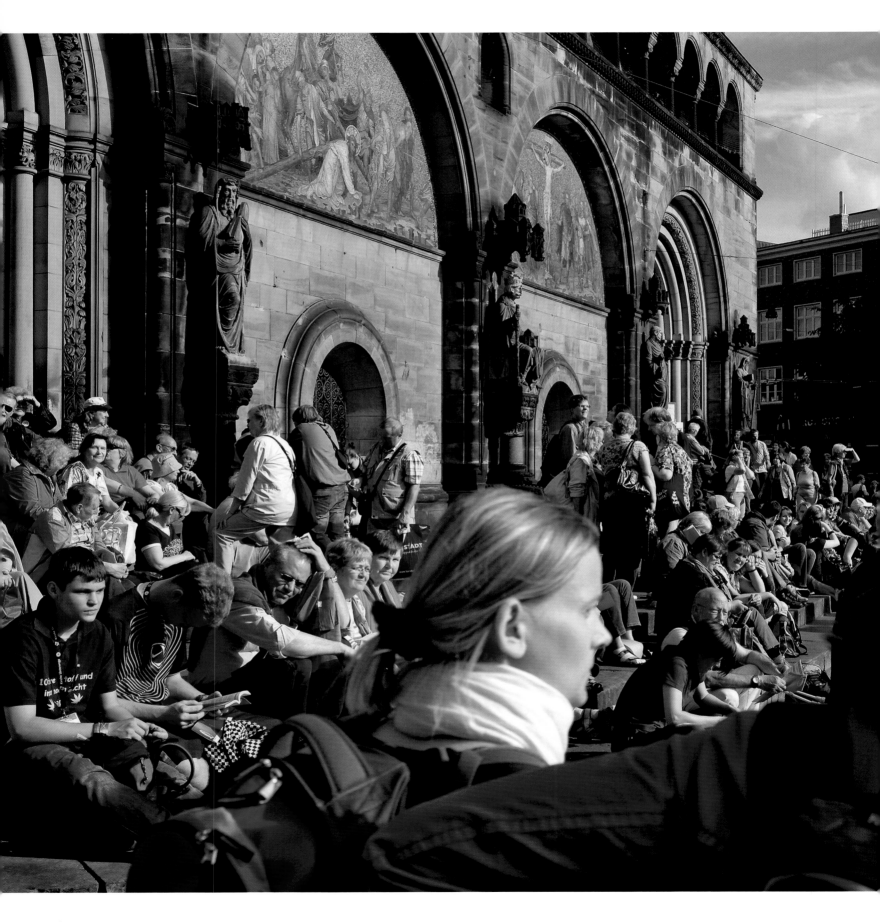

Left:
The steps outside Bremen Cathedral are a popular meeting point – such as here during the Deutscher Evangelischer Kirchentag in May of 2009. One Bremen tradition closely linked to the cathedral is step sweeping, where unmarried men have to brush the cathedral steps until kissed by a 'maiden'.

Below:
One of Bremen's most popular establishments is the Ambiente arts café next to the Weserstadion. It was built in 1929 by the women's temperance movement. Ambiente was opened here in 1983.

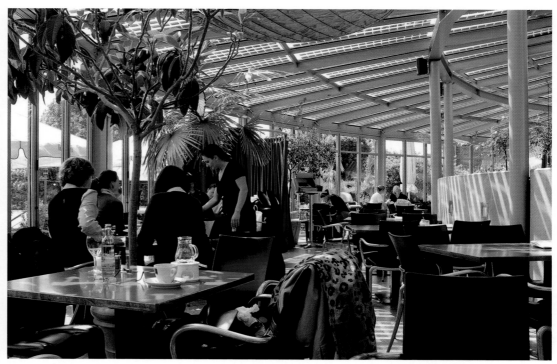

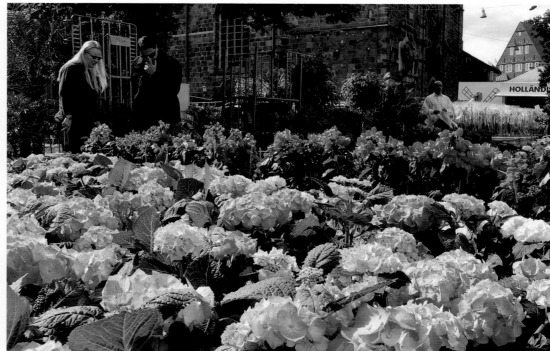

Above:
On a summer's day on the Unser Lieben Frauen Kirchhof square, tucked in between Obernstraße and Sögestraße, locals and visitors alike can enjoy this magnificent carpet of floral blossom.

37

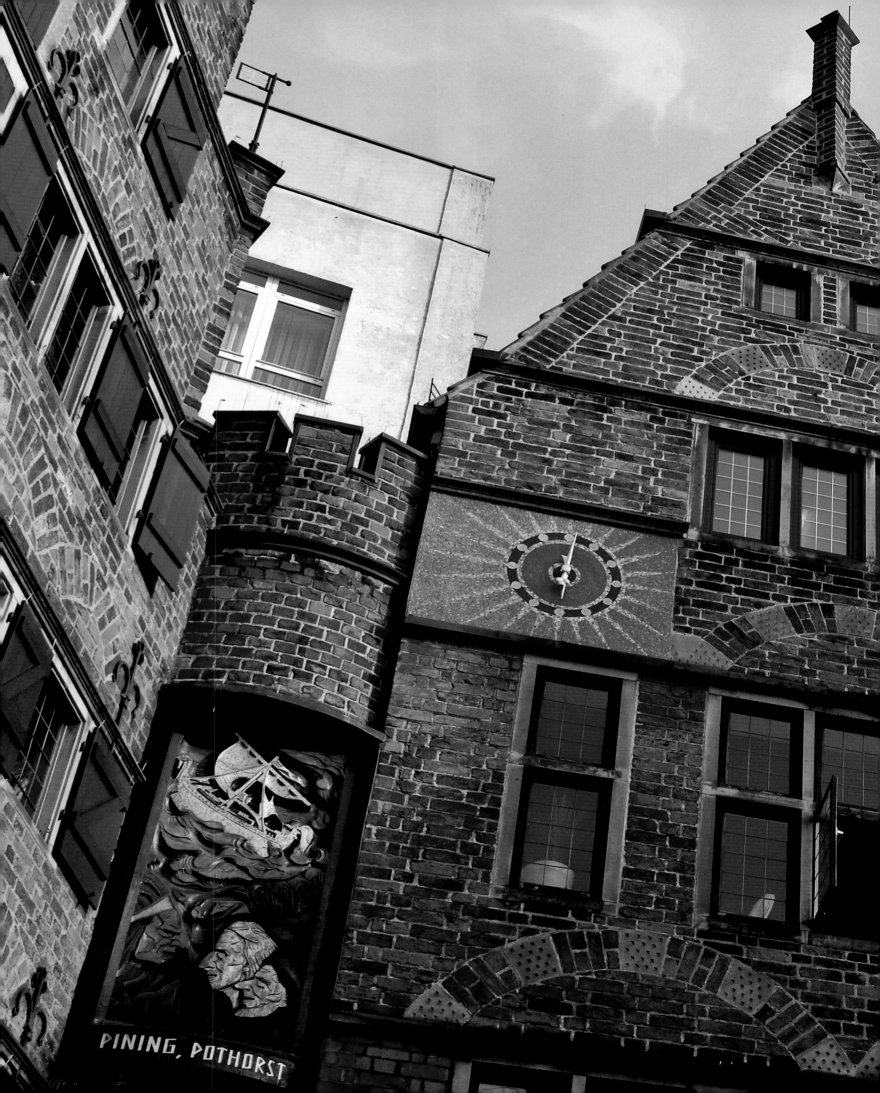

PINING. POTHORST

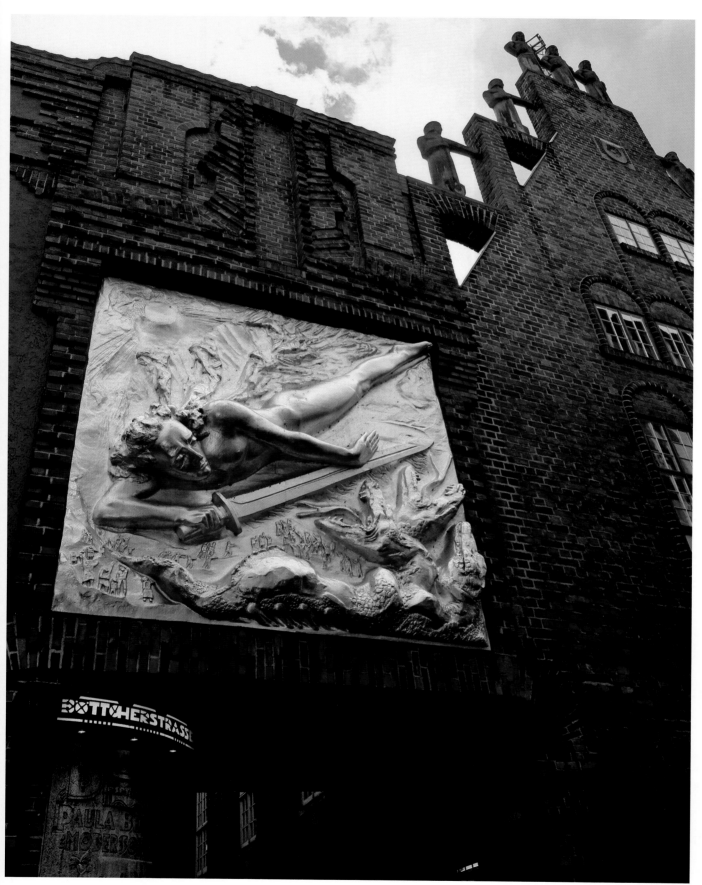

Page 38/39:
*Haus des Glockenspiels
in all its glory. At the top
in the middle are the bells
made of fine bone china
from Meißen. The first
glockenspiel was unveiled
in 1934; a second set was
installed on the roof in
1954. The bells were exten-
sively restored in 1990/91
and given new control
electronics in 2002.*

Left page:
*Looking out over the roof-
tops on Böttcherstraße.
Here you can clearly see
the Expressionist elements
Bernhard Hoetger added
to this part of Bremen.*

Left:
*Visitors to Böttcherstraße
are welcomed by this relief
from 1936, entitled The
Bringer of Light, that was
set into the façade of
Haus Atlantis by Bernhard
Hoetger. With it he wanted
to erect a monument to
Adolf Hitler.*

41

Gable of the Roselius Haus, the first that the Bremen businessman bought on Böttcherstraße in 1902. It initially served as offices for his company Roselius & Co which in 1906 became HAG AG. It was rebuilt in1928 to accommodate the coffee merchant's collection of art.

Entrance to the Roselius Haus. Destroyed in 1944, it was faithfully reconstructed ten years later. The artworks on display here now belong to the Kunstsammlungen Böttcherstraße.

Right page:
Haus der Sieben Faulen was built in the years 1924 to 1927 as offices for HAG AG. This was where the HAG advertising department operated from and also the offices of the Deutscher Werkbund – until they were bombed in 1944. On its reconstruction in 1954 the house was named after Bremen's fabled seven lazy brothers who adorn the gable here in stone.

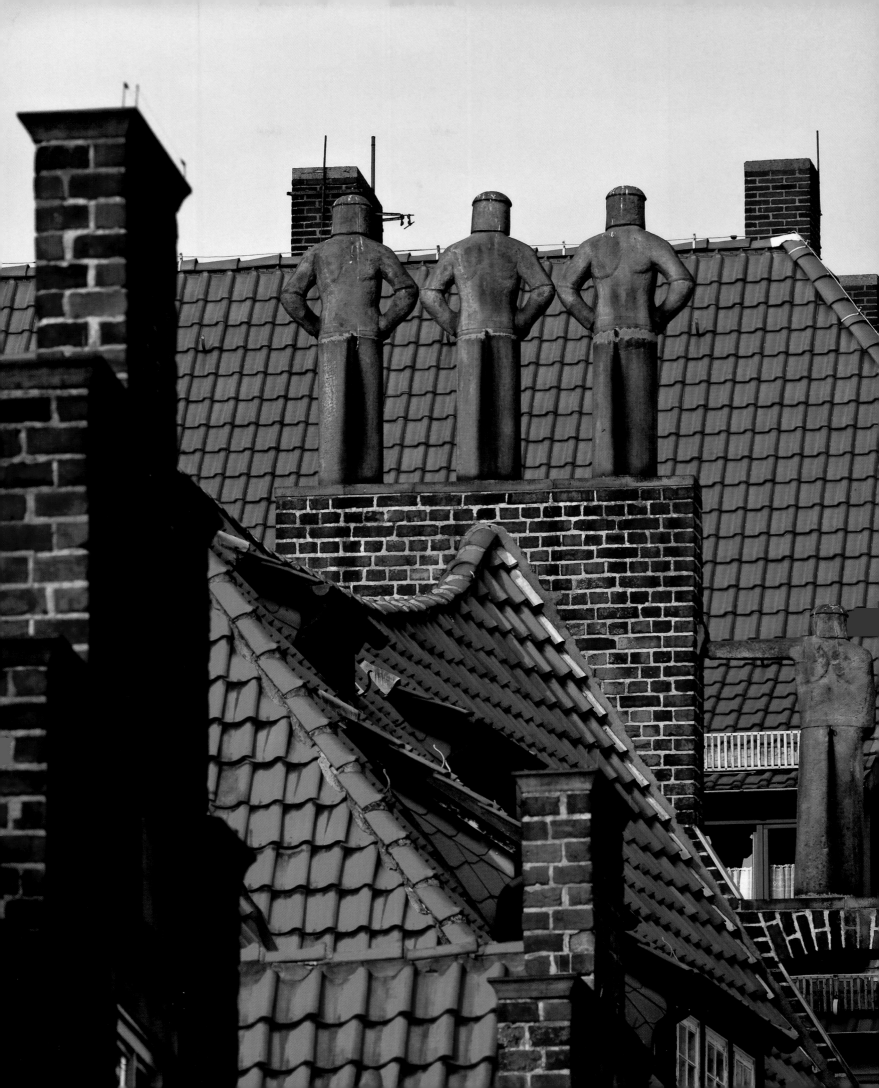

Right:
Bernhard Hoetger has not only left his handprint on the architecture of Bött-cherstraße but also in the various sculptures dotted about town. The photo shows Die Schreitende, his striding woman, from 1936 on the terrace of the Paula-Becker-Modersohn-Haus.

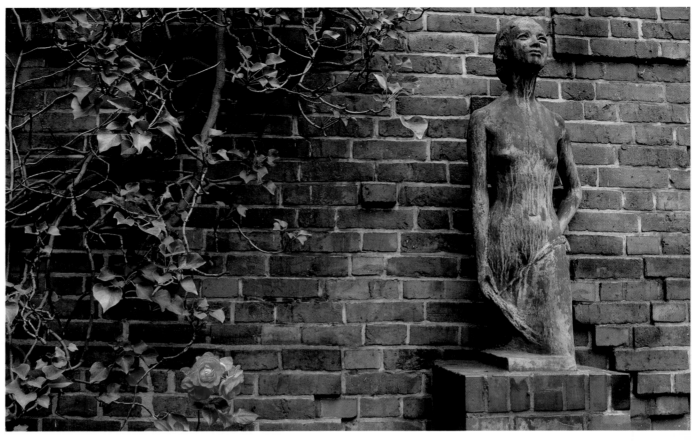

Right:
The sculptures Jugend or Youth (left) and Dämme-rung (Dusk, right) at the Hoetger-Hof are also by Bernhard Hoetger.

Far right:
This statue of the Madonna in one of the arcades on Böttcherstraße is also famous.

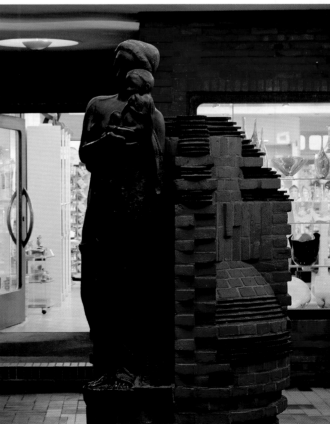

Right:
This bust by Bernhard Hoetger from 1912 is his memorial to businessman Ludwig Roselius. It can be found at the Hand-werker-Hof.

Right page:
Conceived as a complete work of art, even the gates and railings on Böttcher-straße are artistic.

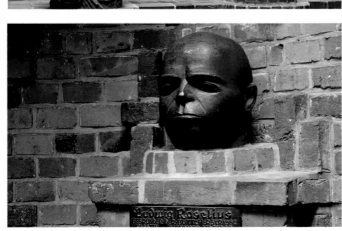

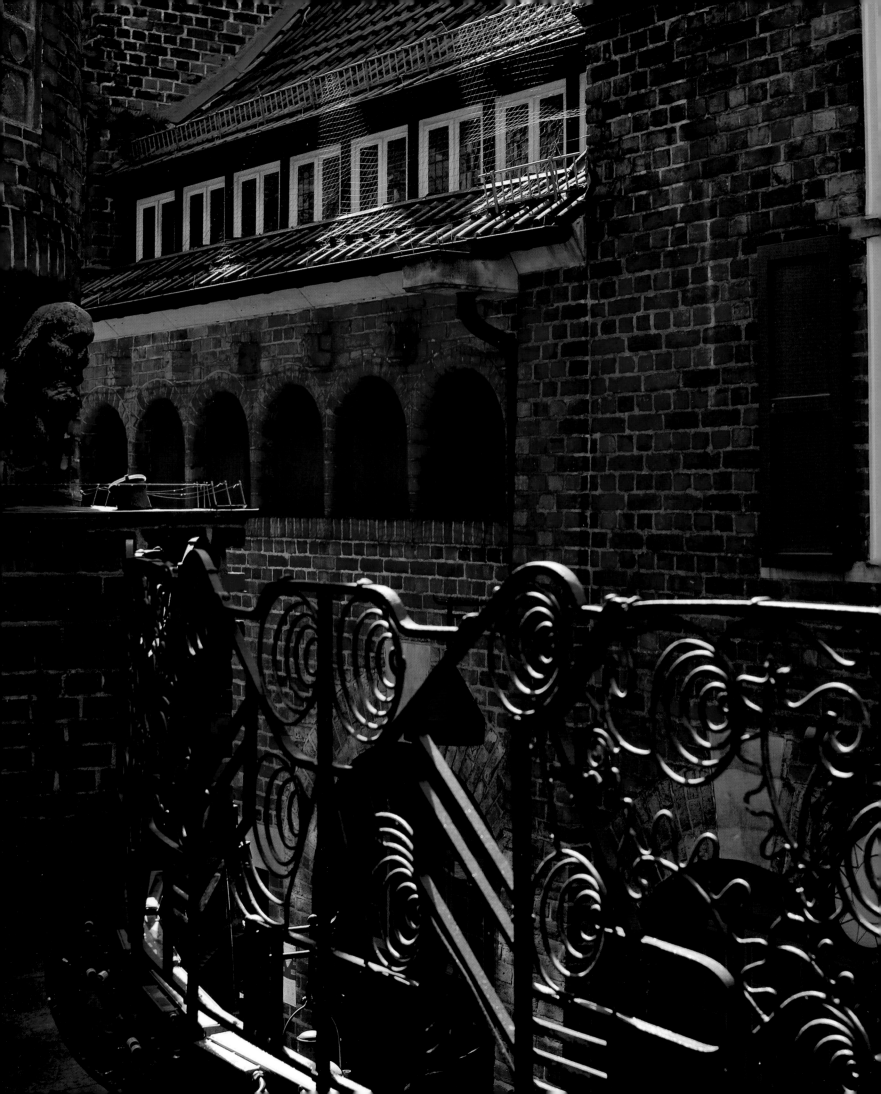

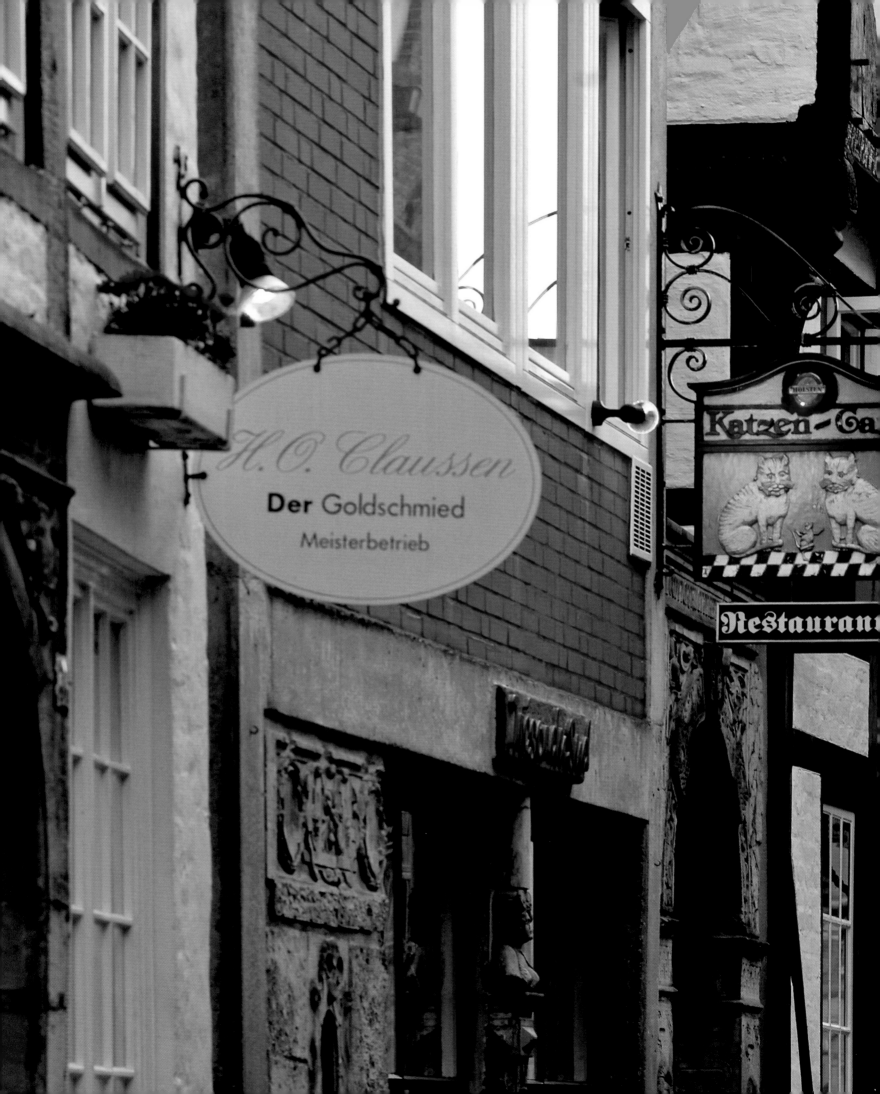

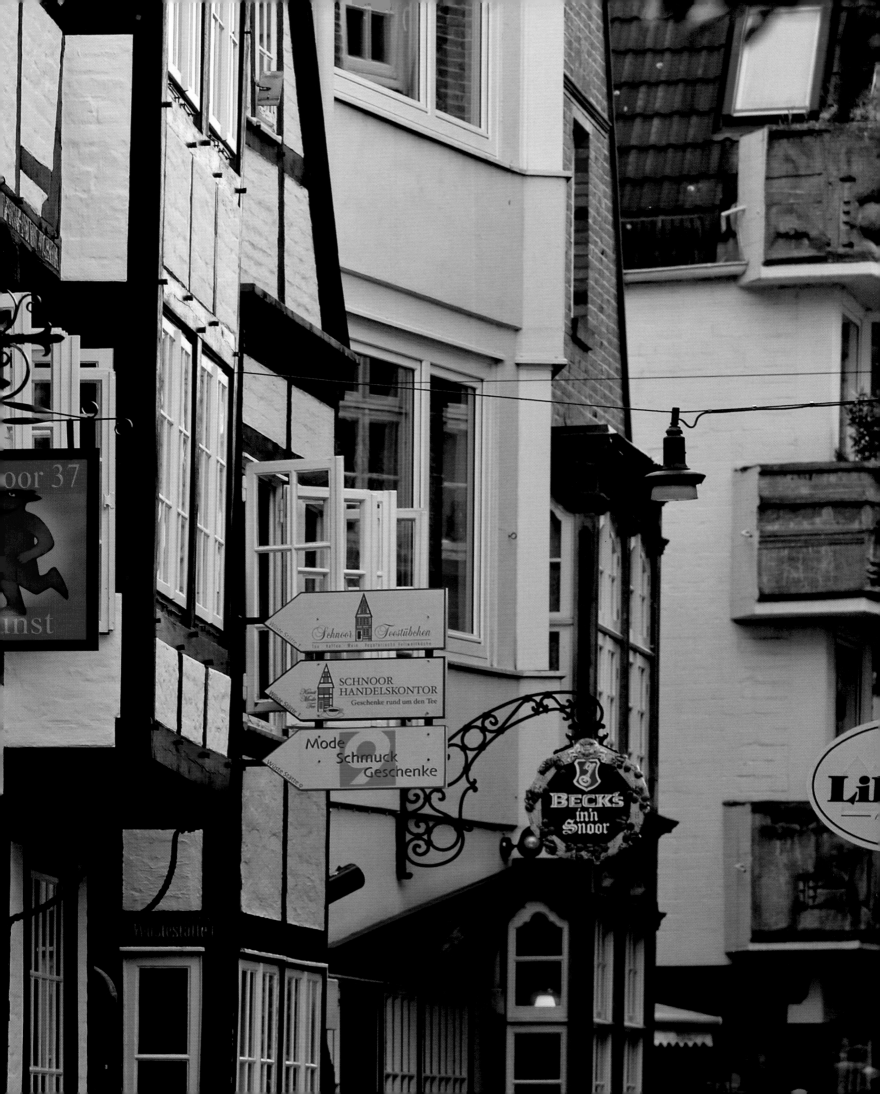

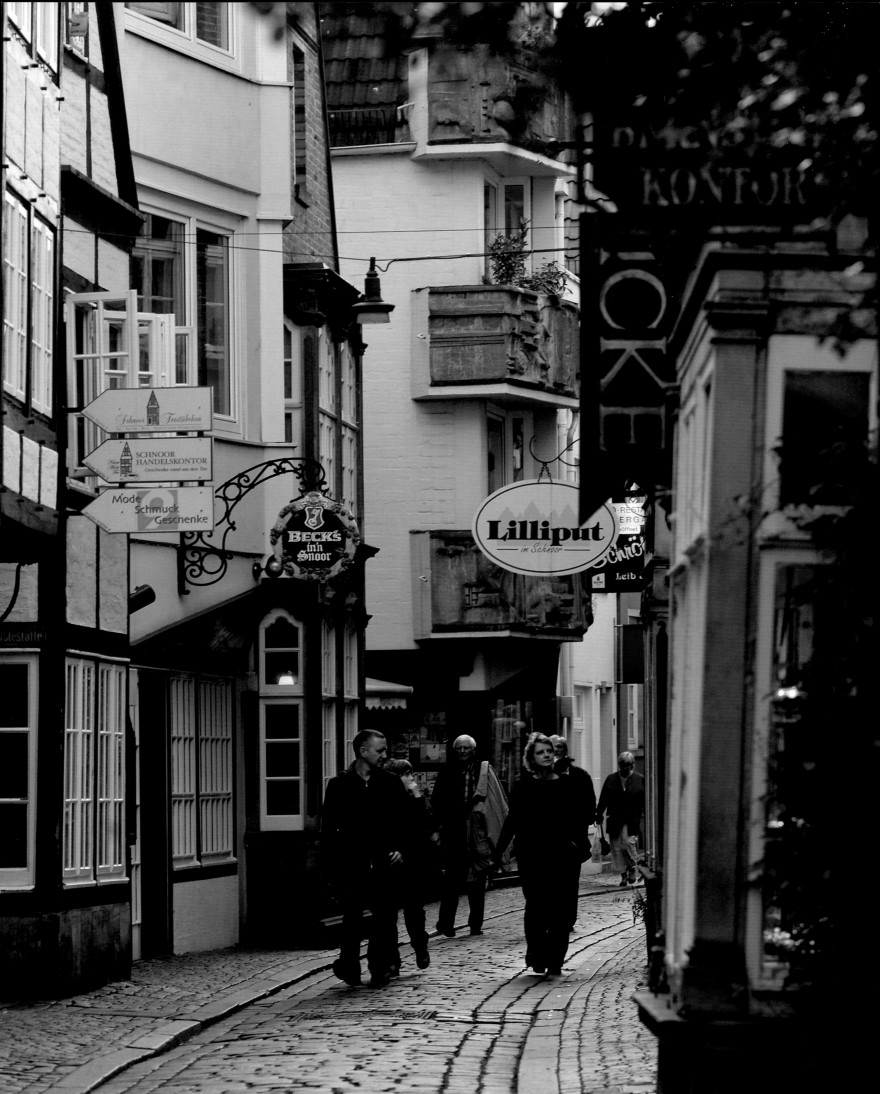

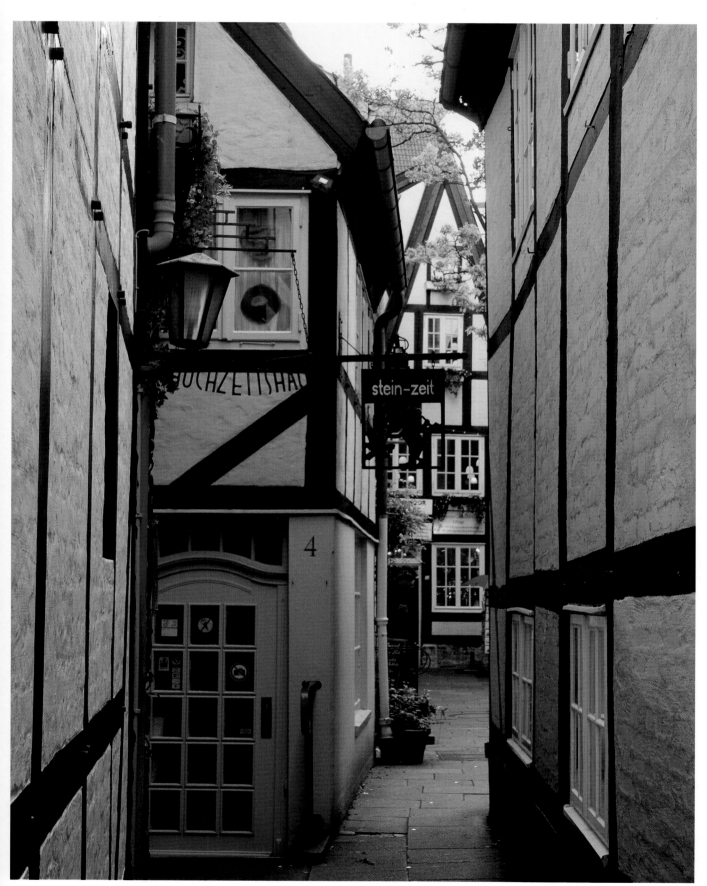

Page 46/47:
Schnoor was once home to the fishing community and is the oldest surviving quarter in the city. It's now a big attraction with its many art studios and craft shops.

Left page:
The streets in the Schnoor are very narrow, just as they were when they were built in the Middle Ages. The old fishermen's quarter was first mentioned in the 13th century.

Left:
The houses in the Schnoor quarter are very close together. It was considered a poor area of town until the early 1970s when it was extensively restored. The word "Schnoor" is Low German and means "string". It indicates that the Schnoor was inhabited not just by fishermen but also by people who made rope for the boats and ships.

Right:
The Schnoor has many quiet corners that effuse a sense of charm whatever the time of year.

Far right:
The Schnoor is now chiefly home to artists and craftsmen. The quarter also has its share of unusual shops, including this one selling amber.

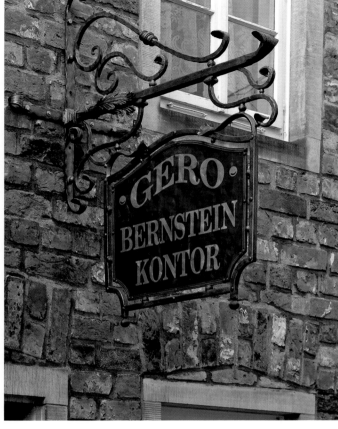

Right:
Bremen's oldest quarter has been restored with great care and attention to detail. Many of its original features have been lovingly preserved.

Far right:
There's not much space in the Schnoor, with doors opening right out onto the pavement.

Right page:
There often wasn't room for trees in the Schnoor. This orgy of green outside Katzencafé (left) thus seems quite exotic.

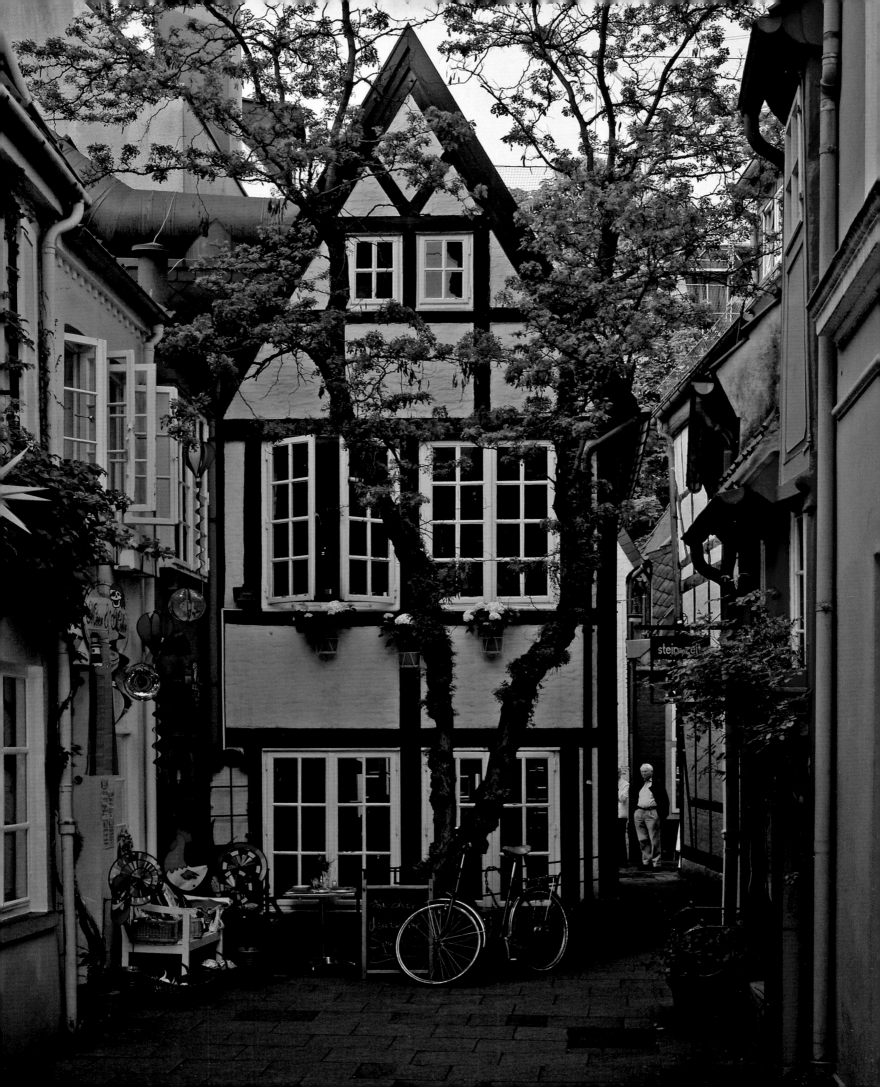

Right:
Ostertorsteinweg, simply known in these parts as "Oweg", is the main street running through the Ostertor quarter. At the beginning of the 1970s the Mozartstraße highway threatened to slice it in two. Thankfully it didn't, making Ostertor now one of the trendiest places to hang out in Bremen.

Right and far right:
The pigs at the entrance to Bremen's Sögestraße are loved by both young and old! Swine were once herded along Sögestraße to the common outside the city gates. "Söge" is Low German for "sow" or "pig".

Right page:
For decades now Obernstraße has been Bremen's high street featuring all the good stores. Here, looking along the street towards the Faulen quarter and Überseestadt.

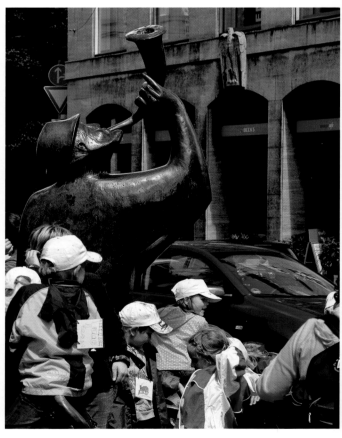

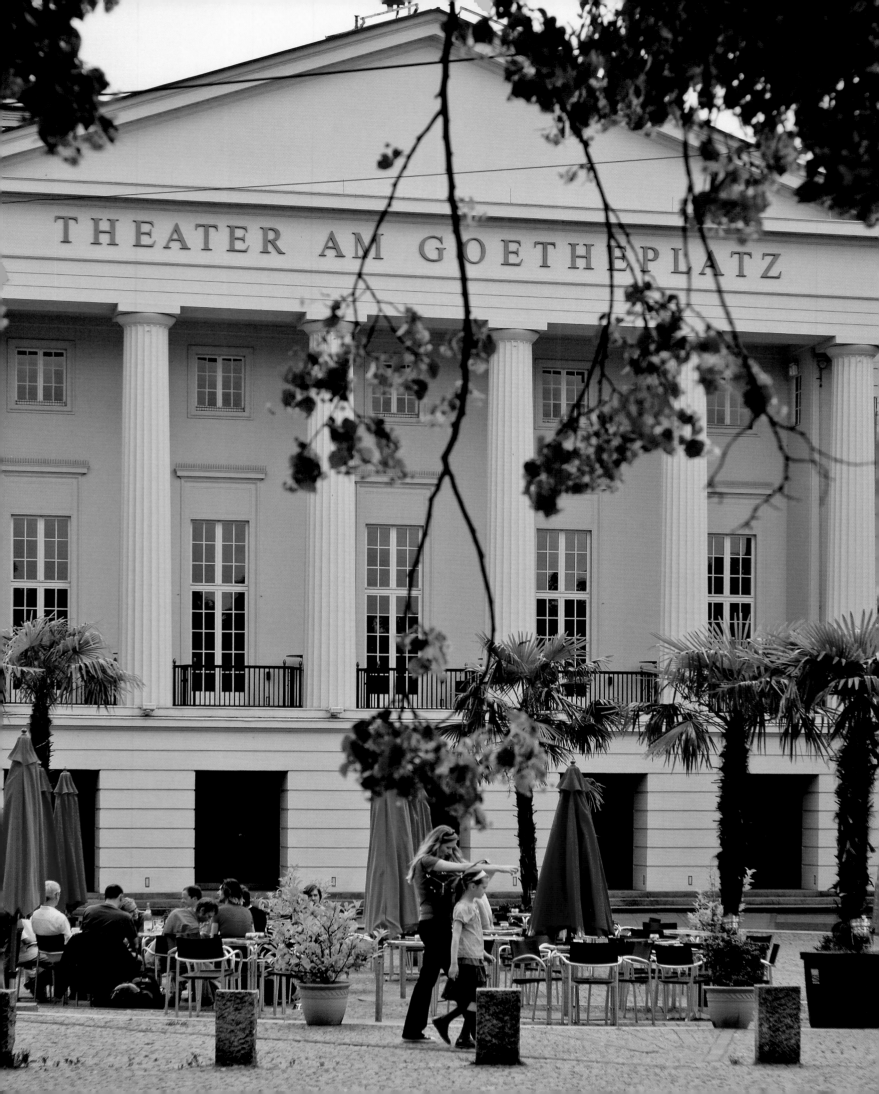

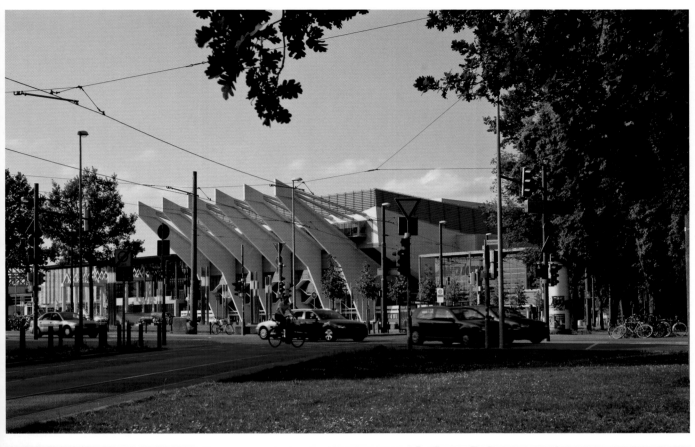

Bremen' Stadthalle or city hall is architecturally the most striking building to come out of the past few decades. Erected between 1961 and 1964 by Roland Rainer, it featured a suspended cable construction that bore the load of the roof, then very unusual. The cables were removed on its rebuilding in 2002–2005 and only the original abutments remain.

Left page:
The theatre on Goetheplatz has been home to the Bremen theatre company since the 1950s. It was built as a playhouse in 1912/13. When the state theatre in the Wallanlagen was very badly bombed in 1943 and not rebuilt, the Goetheplatz building was remodelled to meet new requirements and reopened in 1950.

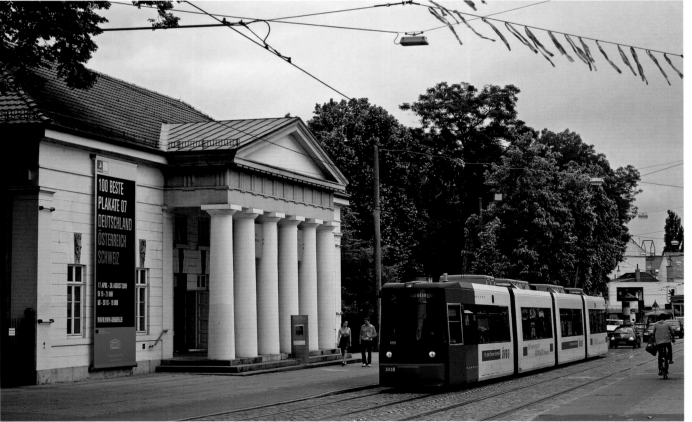

The Wagenfeld Haus opposite the Kunsthalle has housed the Wilhelm Wagenfeld Foundation since the 1990s and administers the estate of the designer who died in 1990. The building is part of what was the Ostertor guardhouse erected in 1825. It also includes the Gerhard Marcks Foundation.

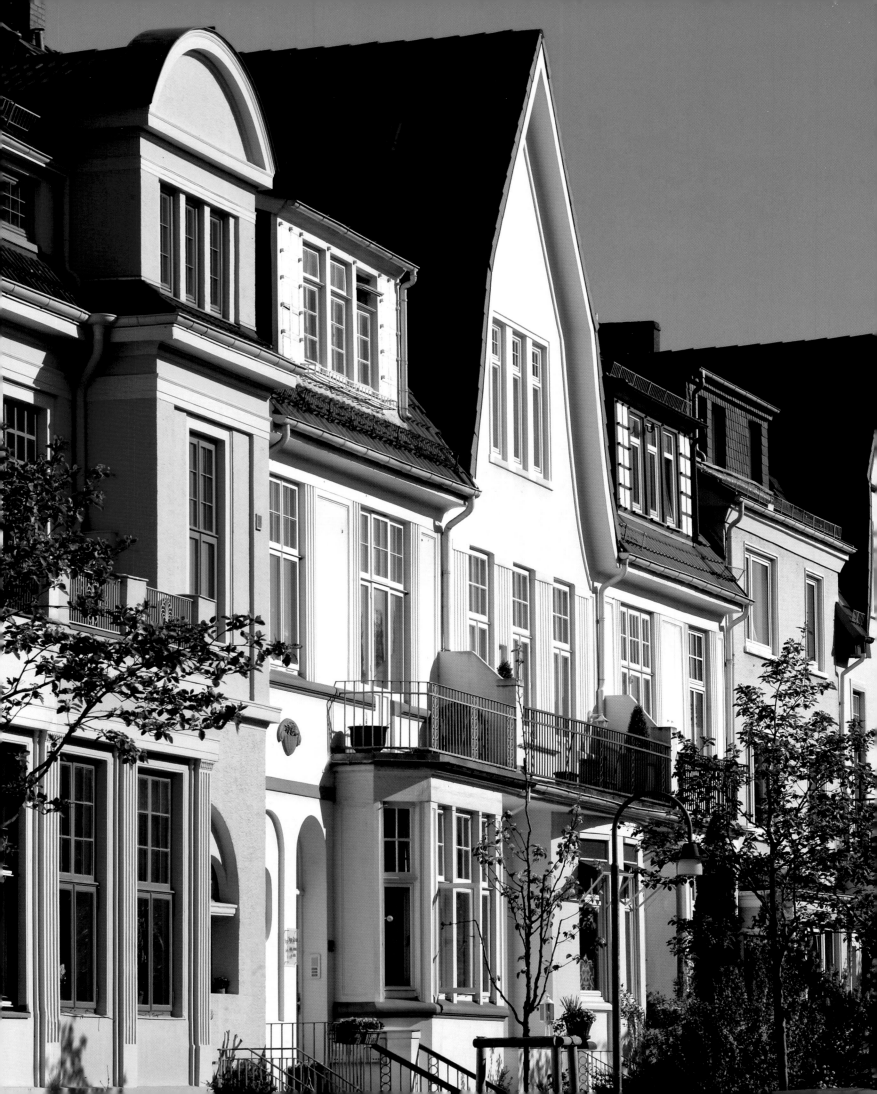

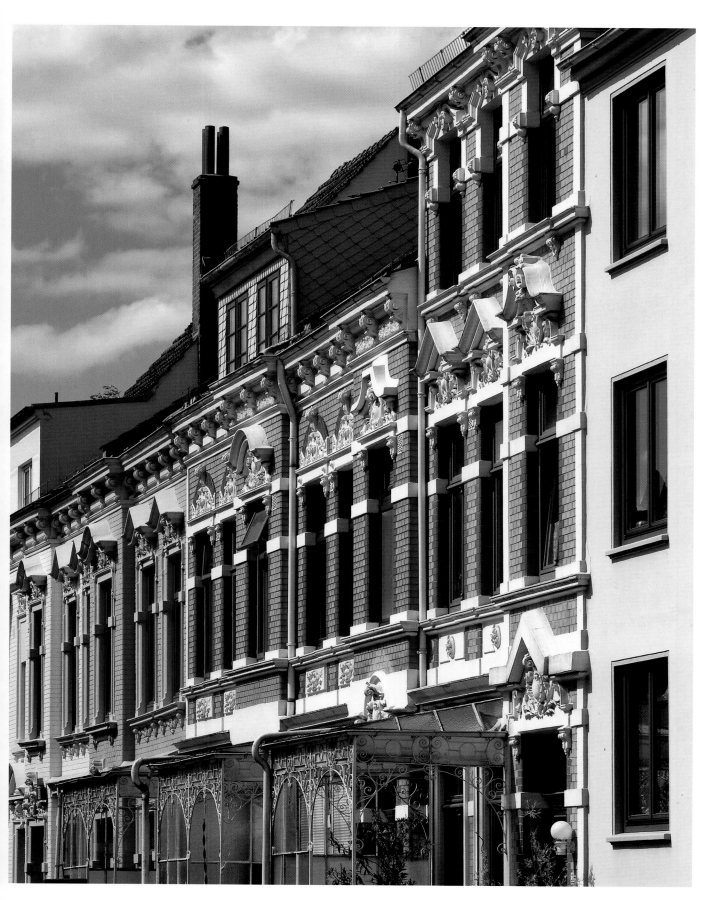

Page 56/57:
This Japanese cherry brings a touch of the exotic to the North German Plains, here in flower outside a Bremer Haus.

Left page:
Straßburger Straße in Schwachhausen is part of the French quarter. Here, too, the Bremer Haus is in abundance.

Left:
Many examples of the Bremer Haus come with a glass veranda. These small terraced houses have made Bremen the city with the highest percentage of homeowners, the current quota being over 38%.

Right:
On Osterdeich on the River Weser the style is more palatial, with bourgeois villas the order of the day.

Far right:
Jugendstil permitted the building of towers and turrets in accordance with the motto "My home is my castle." Here, a villa on Osterdeich.

Right:
This Bremer Haus on Ostertorsteinweg is decorated with many wonderful Jugendstil ornaments.

Right page:
Another composite part of the Bremer Haus is the front garden, here in the heart of Schwachhausen. Many of these dwellings have been passed on from generation to generation.

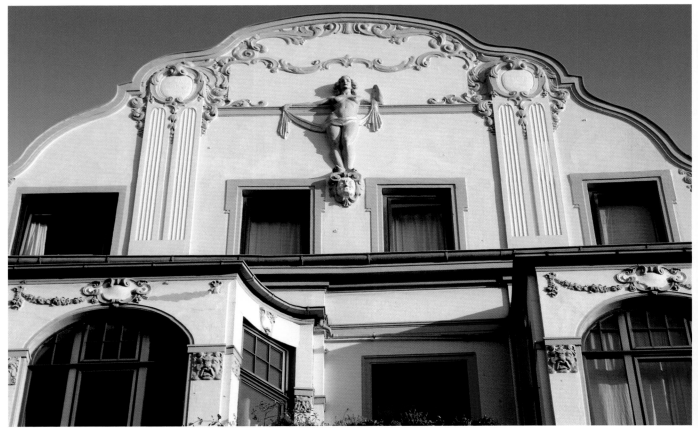

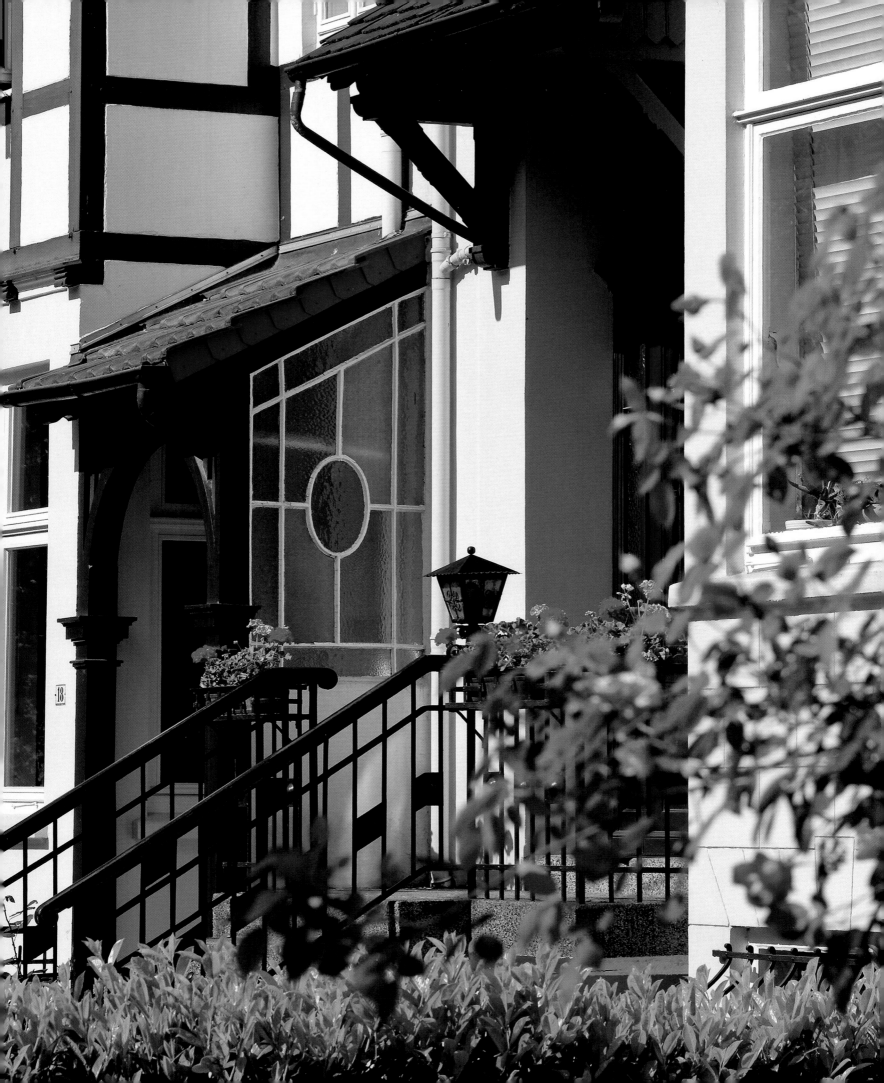

BREMEN ARCHITECTURE – TWO UNIQUE EXAMPLES

The cityscape of Bremen is unique and absolutely unmistakable in its design. Largely built between the late 19th century and the 1930s, in many parts of town an architectural rarity has been created which has become known as the Bremer Haus or Bremen house. These historic terraces can be found in abundance in Schwachhausen but also in Ostertor and Steintor. There are also rows of the Bremer Haus in Findorff, Walle and Gröpelingen although many fell victim to the heavy air raids of the Second World War.

The second novel example of Bremen architecture is Böttcherstraße. It was erected in the 1920s and 1930s from plans drawn up by Worpswede architect Bernhard Hoetger. The project was commissioned by Bremen businessman Ludwig Roselius, he of Café HAG and the instant chocolate drink Kaba.

The Bremer Haus

Whether festooned with stucco or simple in its exterior, wide and generous or slim and modest, each Bremer Haus was slightly different, with the amount of sumptuousness in direct proportion to the size of the owner's wallet. The basic principle is, however, the same: the house was built deep and long but not wide so as not to waste precious space within the confines of the city. This was also why the houses were terraced.

As the Bremer Haus was built well into the 1930s it spanned three architectural genres: Historicism, neoclassicism and Jugendstil or Art Nouveau. This is perhaps what makes the Bremer Haus so interesting.

A typical Bremer Haus has two large main rooms, one beyond the other, a stairwell to the side leading up to the upper storeys, of which there are one or two, and a generous porch. Every Bremer Haus also has a basement one to two metres below street level. In the well-heeled suburbs of Bremen this is where the servants lived and where the kitchen, pantry, laundry and the like were situated. The basement was partly underground because the street level had been deliberately raised. In the sections of town close to the River Weser this was done to prevent flooding. This also explains why to the rear of the house the basement was level with the back yard or garden.

Entire streets of the Bremer Haus paint a uniform picture, created by one building contractor charged with erecting the entire block. To make the street less monotonous homeowners had various details and elements of design added. The Bremer Haus itself evolved for a number legal, social and economic reasons. Up until 1888 Bremen was booming. As far as customs and excise were concerned, the harbours were foreign territory, meaning that plenty of tax money was generated. To avoid losing capital to exchange rates, much of this was invested within the city limits – with the majority of the profits being sunk in property. There were soon plenty of houses on the market which in turn slashed prices, making the Bremer Haus a viable proposition for wide sections of the population. Even when the cost of land increased once Bremen joined the German Customs Union, the Bremer Haus continued to dominate the townscape. Another factor that promoted its proliferation were the city building regulations of 1841 which prohibited the building of tenement housing or development of the 'backs' behind the houses. This decree was lifted at the beginning of the 20th century but the tradition of the Bremer Haus continued until well into the 1920s. Only then did the first tenement blocks begin to pierce the Bremen skyline.

Böttcherstraße

One of the very few examples of Expressionist architecture to have survived is Böttcherstraße. At the beginning of the 20th century Ludwig Roselius bought the first house on the street whose history goes back to the Middle Ages. Böttcherstraße went Expressionist during the

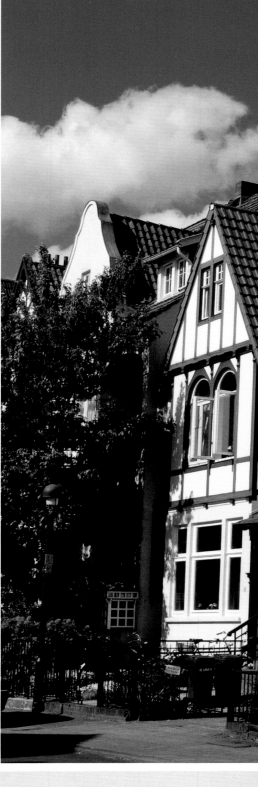

Left:
The houses on Hermann-Böse-Straße erected by building contractor Wilhelm Blanke in 1902 have been almost completely preserved. The statue of Emperor Friedrich III in the foreground was donated by businessman Franz Schütte in 1905.

Far left:
During the correction of the River Weser at the end of the 19th century a new dike was built. The marshes beyond it were filled in so that they could be

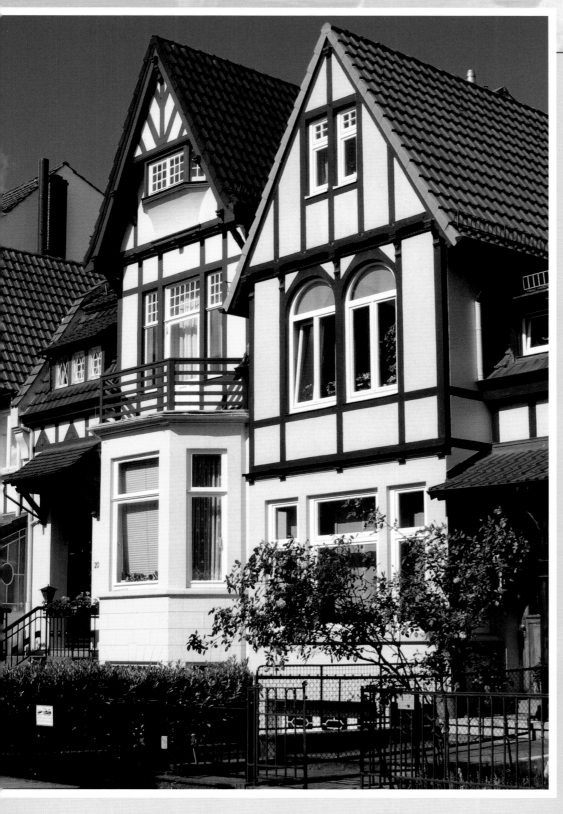

1920s when Bernhard Hoetger began redesigning it in accordance with Roselius' visions and desires. In 1921 what is now the Roselius Haus was turned into a museum. In 1926 the house associated with Paula Modersohn-Becker also became a museum, with Haus Atlantis and also the Robinson Crusoe Haus being refurbished five years later. When the ensemble was finally finished the Nazis came to power, slapping a preservation order on Böttcherstraße as an "example of the decadent art of the Weimar Period".

developed for housing. The Osterdeich was created and later the teacher training college on Hamburger Straße (front right). The latter is now a high school.

Above:
Older versions of the Bremer Haus were very individual in their design, more so than their younger counterparts. This row is in Schwachhausen.

Top right:
The Bremer Haus spans three epochs: Historicism, neoclassicism and Jugendstil. The décor was always in keeping with fashions of the day.

Right:
The lovingly kept Bremer Haus is a joy to behold, with many splendid details to admire.

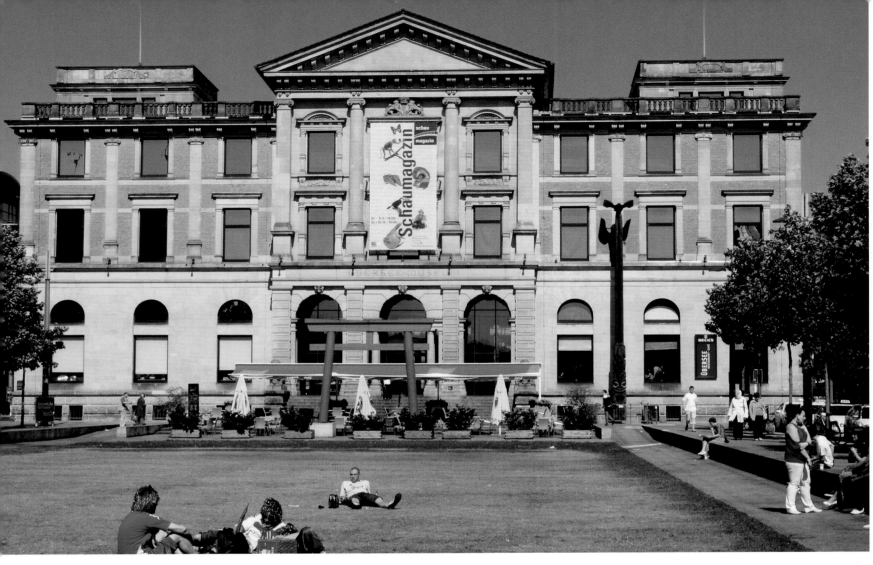

Above:
The merchants of Bremen were always keen to establish trade links with the rest of the world. They had their ships bring back many treasures from Africa and Asia which have been on display since the beginning of the 20th century at the overseas museum next to the main station.

Right:
For centuries Bremen has been a leading international cotton trader. This is documented by the permanent display at the Speicher VI harbour museum in Überseestadt.

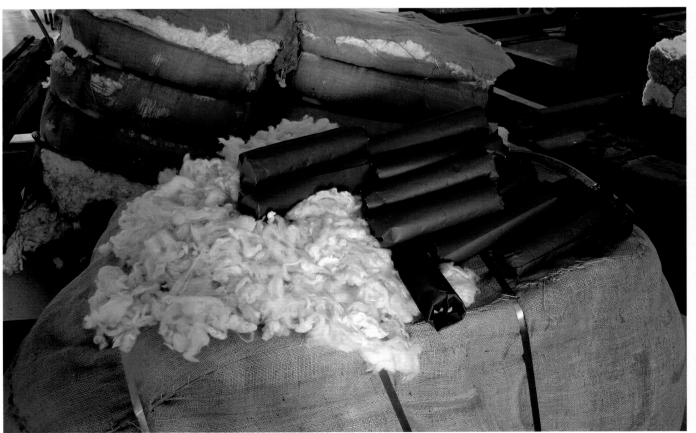

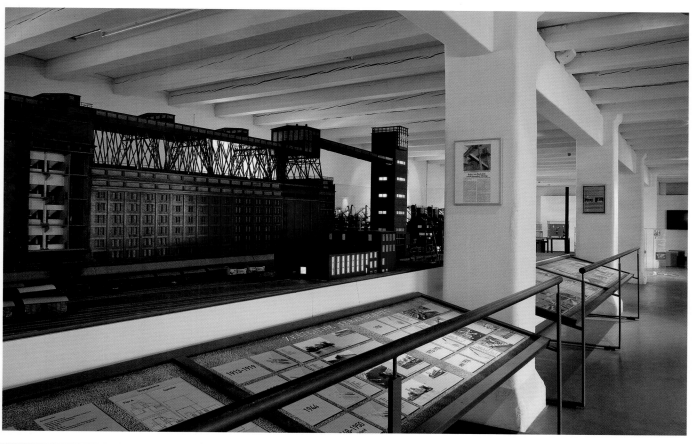

Left:
The Speicher VI harbour museum also has a model of the grain store. It was built from 1914 to 1916 and first extended between 1926 and 1929. It is still one of the largest industrial buildings in Europe. The original is in the grain harbour.

Below:
The name Borgward is inextricably linked to Bremen. Until it went bust in 1961, the factory made such elegant-sounding cars as the Isabella (photo, on show at the Focke Museum) and the Hansa Lloyd, otherwise known as the Leucoplast bomber for its plastic bodywork. One local saying went, "If you're not afraid to die, drive a Lloyd!"

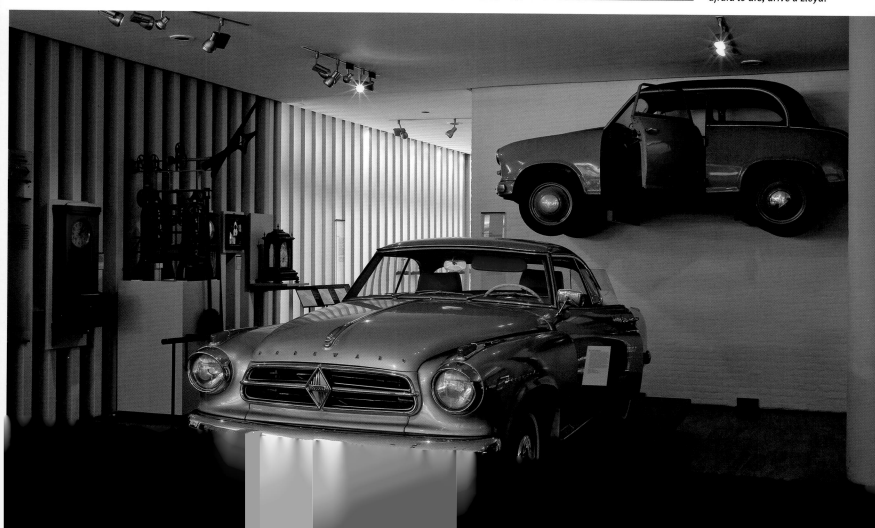

Right:

Bremen is also home to the aviation industry. To demonstrate this, visitors arriving at the local airport are greeted by models of the International Space Station. The European Space Agency has now commissioned the Columbus science lab to be built in Bremen.

Below:

At the end of the 1990s loud cries of "We're bringing the Bremen back to Bremen!" echoed up and down the Weser Valley. The jubilation marked the return of the Junkers W 33 to the place that gave it its name. The plane built at the Junkers factory in Dessau was the first to make a non-stop Atlantic flight from west to east in March 1928. The Bremen is on display in the Bremen Hall at the airport.

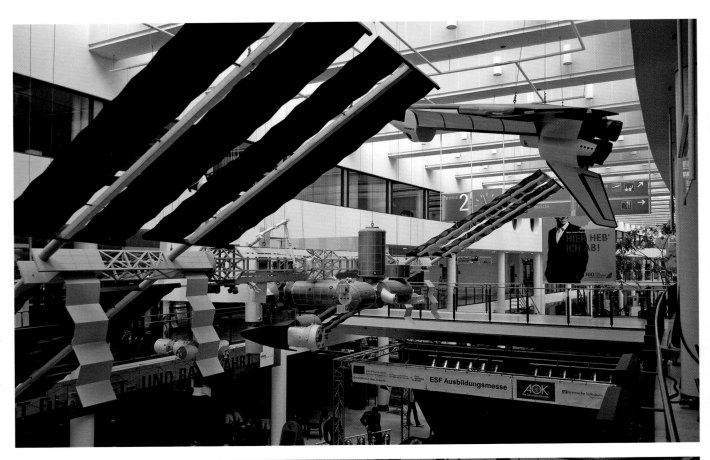

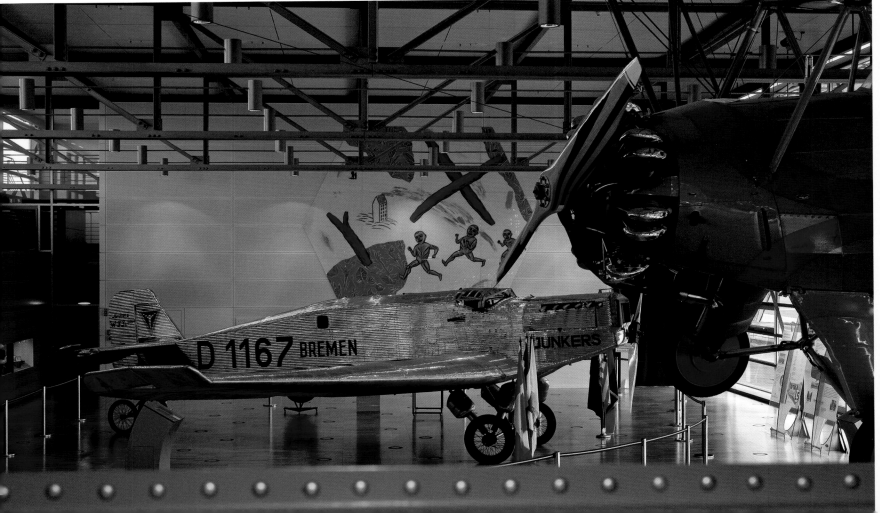

Above:
You can have fun with science close to at the Universum Science Centre next door to the university of Bremen, opened a good ten years ago. Here, visitors of all ages can travel back in time to investigate the origins of man and the cosmos and generally explore a whole range of scientific phenomena.

Left:
They helped developed the first German jet plane, the VFW 614, after the Second World War, where the engines were typically affixed on top of the wings: Hans-Joachim Pompe (left) was production manager and Rüdiger Otte design engineer.

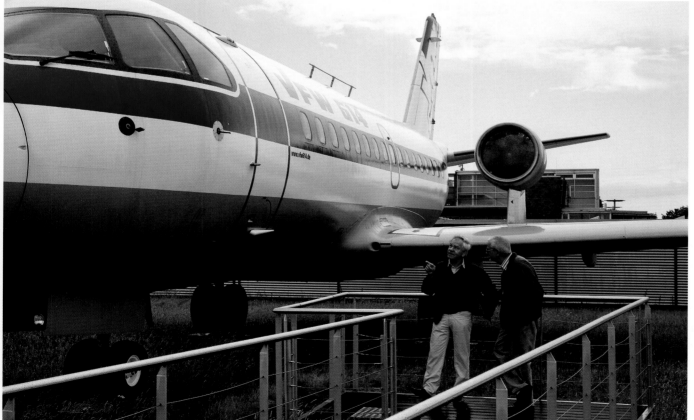

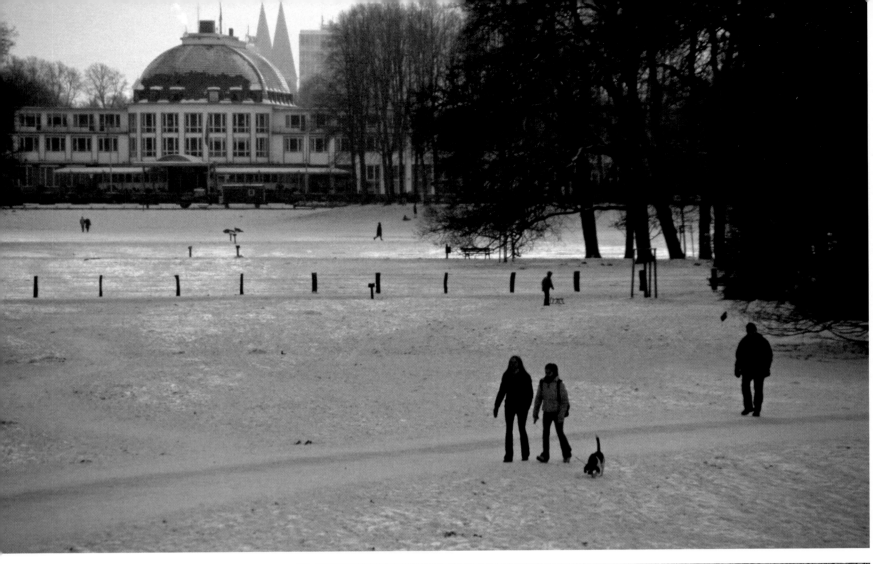

Above:
The Parkhotel presides over the snowy lawns of the Bürgerpark. The present building dates back to 1954 after its predecessor was obliterated during a World War II air raid. The architect was Herbert Anker. Beyond the hotel are the twin spires of the cathedral.

Right:
The Bürgerpark is Bremen's largest open green space used by the citizens all year round. Most of the park benches have been donated by the local inhabitants; on very cold days, however, they go largely unused.

Page 70/71:
Walking from the Bürgerweide or common to the Bürgerpark, the first thing you see is the Parkhotel. In front of it is the Hollersee where each year the Bremen youth orchestra stage their much-frequented Musik und Licht am Hollersee event, a concert of music and light on the lake.

Left:
Respite from the hustle and bustle of the city can be found in the Bürgerpark where deer also graze beneath the shady trees.

Below:
View from the Parkhotel of the Meierei, one of the park's service buildings used by the Bürgerpark-verein, the society active in the upkeep of the park.

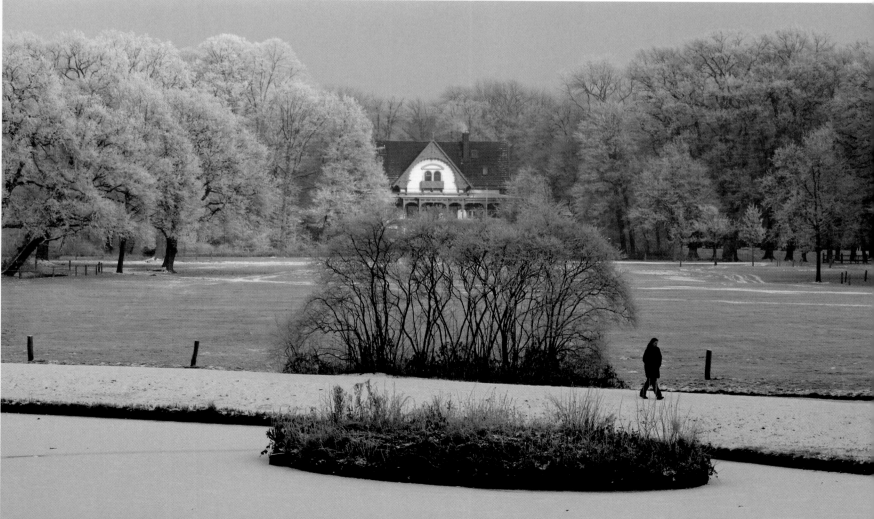

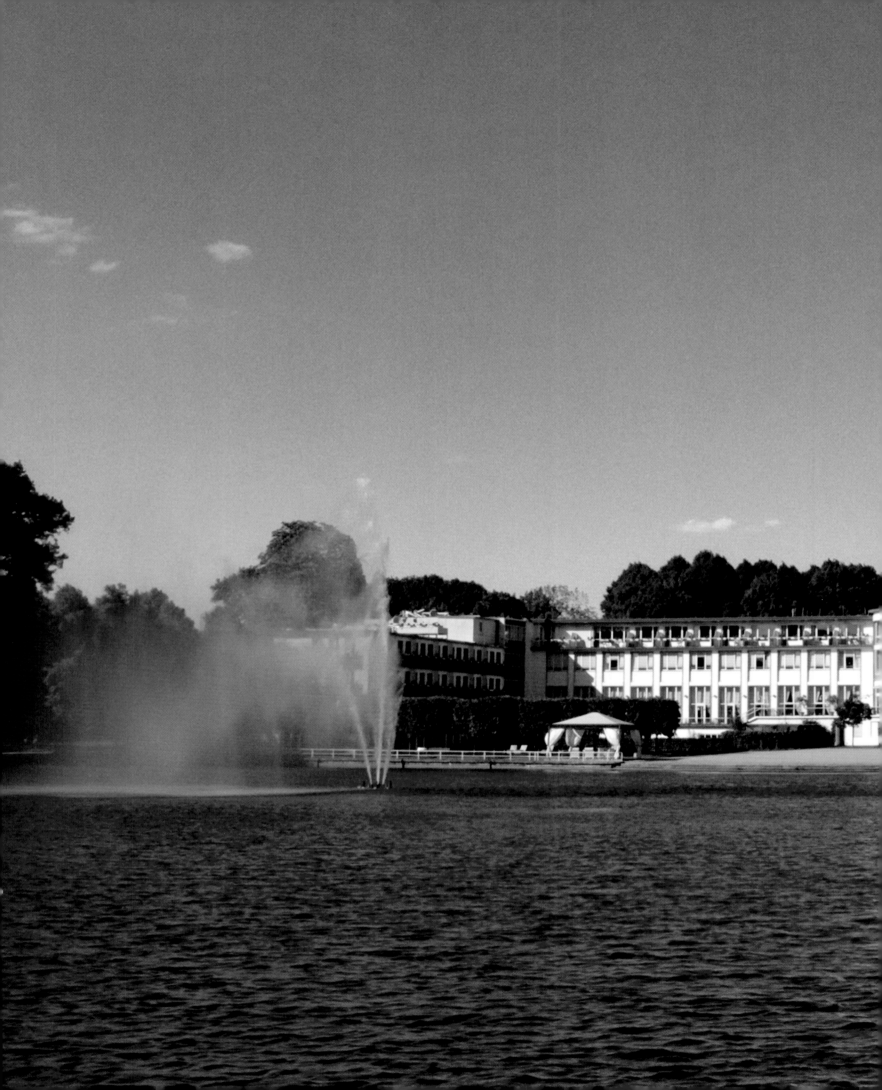

Above:
Around 300,000 guests from all over the world visit the rhododendron park each year. The huge gardens boast a unique collection of rhododendrons and azaleas.

Right:
The park isn't just rhododendrons. Laid out in 1933, it also has several statues, including this one of Spring (shown here) and a sculpture entitled "Wisent".

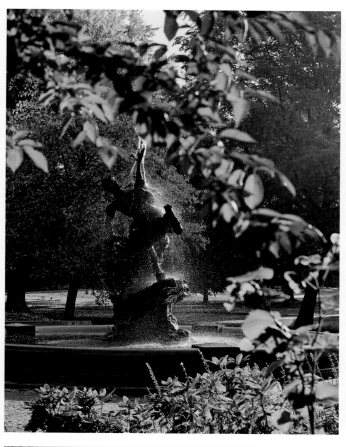

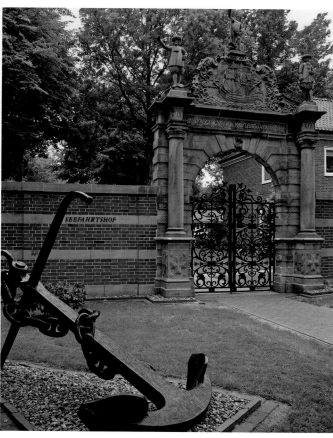

Far left:
This centaur fountain was sculpted in 1891 and moved to the Wallanlagen in the Neustadt near Leibnizplatz in 1958.

Left:
Haus Seefahrt is in Grohn, the northern part of Bremen. The foundation is the oldest charity in the world, set up in 1545.

Below:
Bremen's botanical gardens are appropriately situated in the middle of the rhododendron park and feature both regional species and also exotic plants from far-off continents.

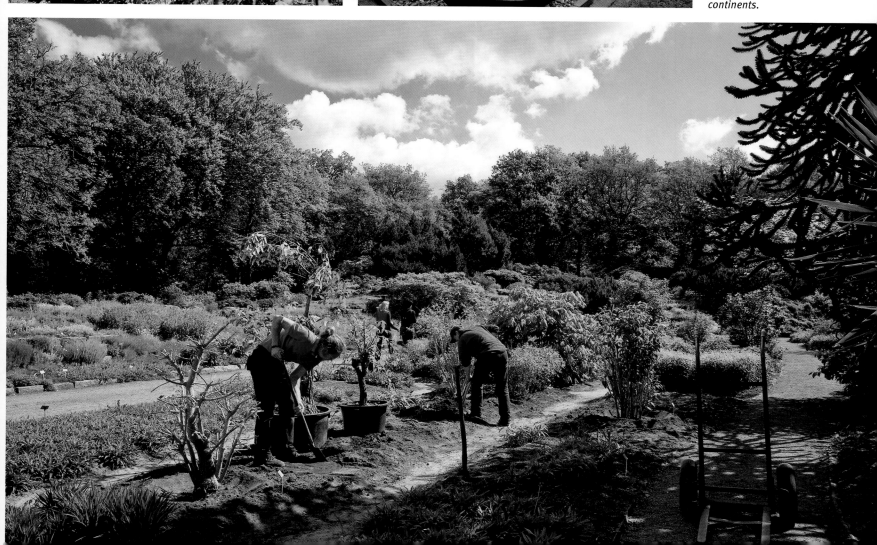

Right page:
The windmill in the Wall-
anlagen. The park marks
the site of the old city
defences (hence the name
"Wall") that stood here
until the 17th century. The
windmill, called the Mühle
am Wall or Herdentors-
mühle, was in operation
until 1942. It was completely
restored in 1998 and is
now a restaurant.

Right, top and bottom:
The Wallanlagen was
the first public park in
Germany to be founded
by a representative body
of the people. Since its
opening, the green belt
that almost completely
encircles the old town has
proved extremely popular.
The park also doubles as a
pleasant venue for various
cultural activities.

Page 76/77:
"New from old" has been
the motto of Bremen's city
port for the last ten years.
Überseestadt is currently
the biggest redevelopment
project in Europe. The
undertaking also affects
the Speicherstadt or ware-
house quarter with its
Europahafen.

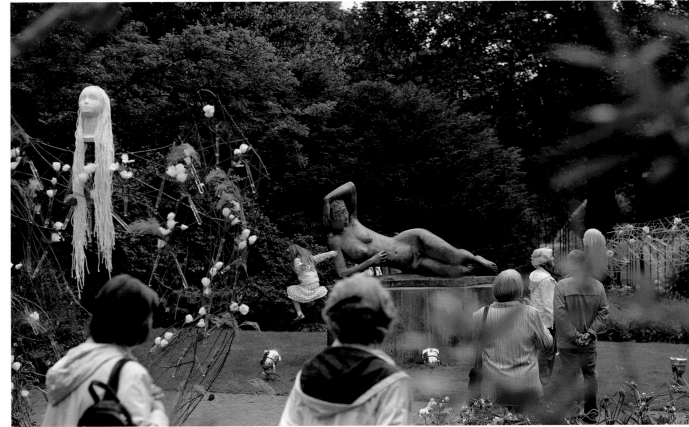

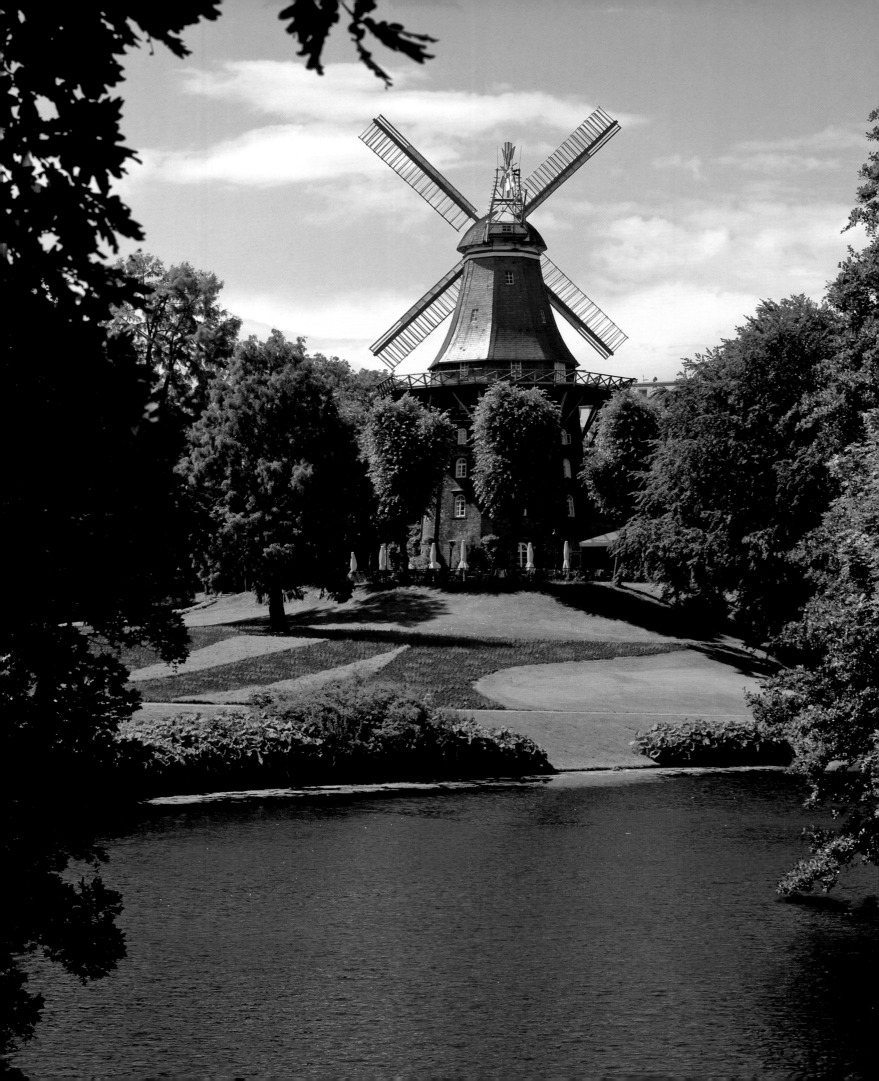

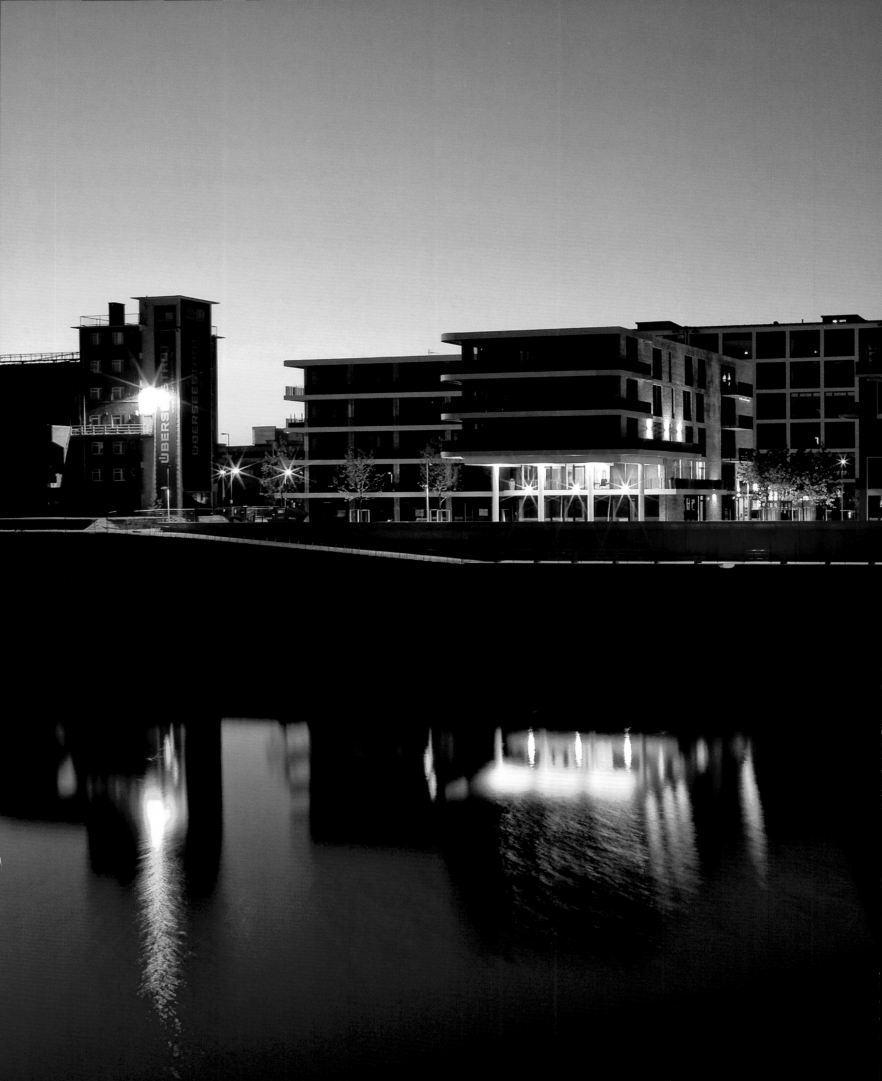

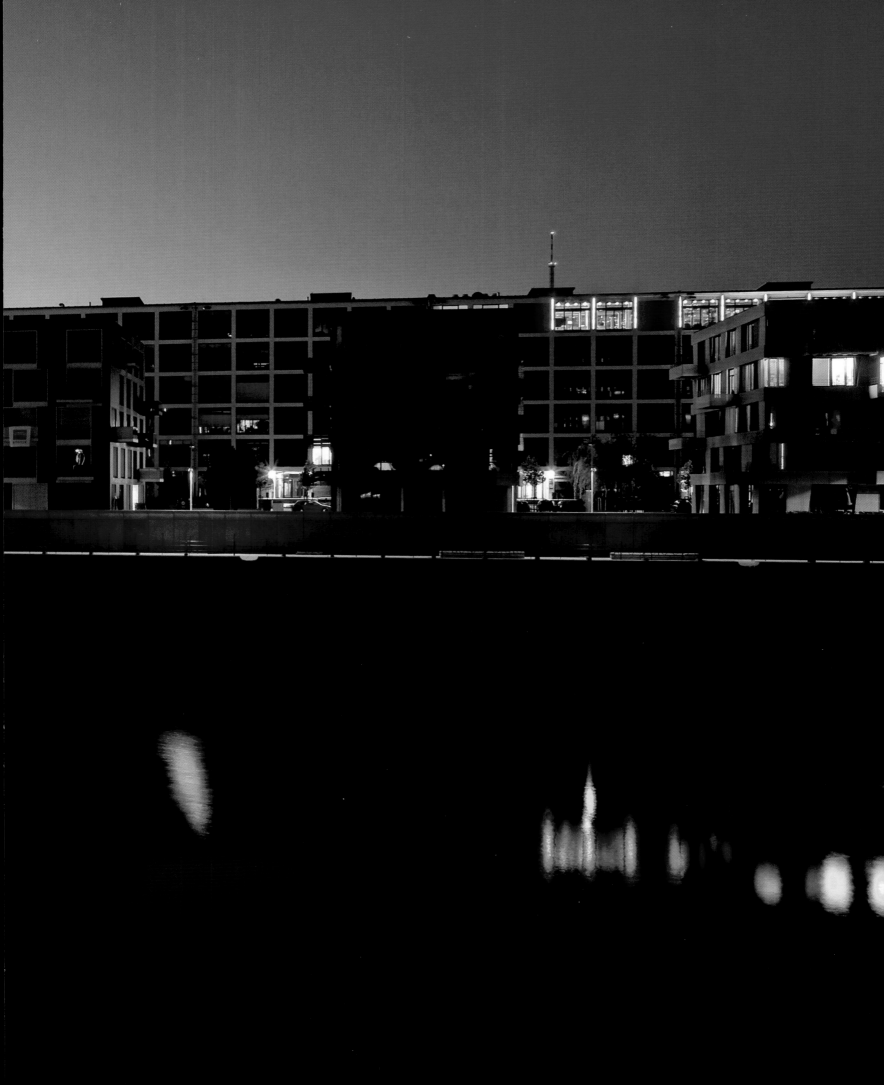

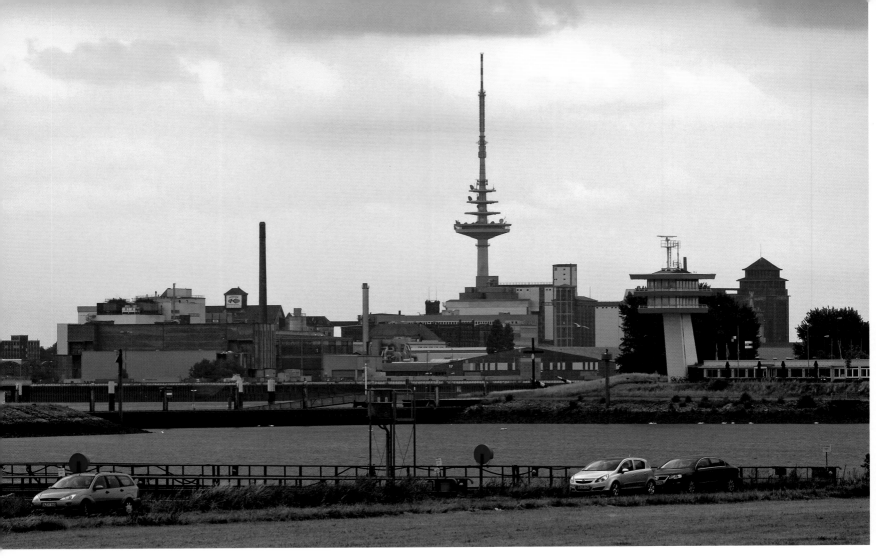

Above:
The best view of the harbour is to be had from the 'left' bank of the Weser, as the people of Bremen refer to it. Seen from Hasenbüren the skyline of the old port area is particularly impressive, with the telecommunications tower sticking up in the centre.

Right:
There's a cult pub at the top end of the wood and factory harbour. The last remaining casino in the port is called Truckstop and is where builders and craftsmen, advertising agency staff, students from the arts academy, prostitutes and dock workers hang out.

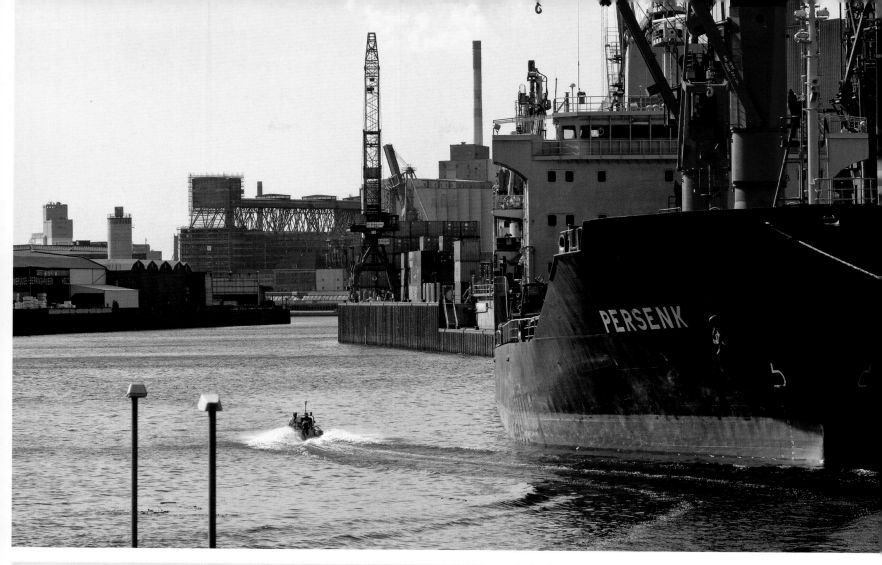

Above:
The wood and factory harbour is at the end of Überseestadt. Fish food is landed and immediately processed here. This part of the docks is where you can really get a feel for what it used to be like here in Bremen's heyday as an international port.

Left:
The boats of the waterways and shipping office are moored on the left bank of the Weser. Bremen's giant grain store positively dominates the opposite side of the river.

BROWN CABBAGE, SAUSAGE AND SCOUSE: CULINARY BREMEN

Even if its culinary specialities are not exactly world famous, the Hanseatic north has plenty to offer in the way of good food. The best-known dish in these parts is probably Bremen's *Braunkohl mit Pinkel* ("brown" cabbage and sausage). This isn't just a meal; it's a philosophy! The cabbage in question is green – which is why in the Oldenburger Land and practically everywhere else it's referred to by its true colour. But not in Bremen. Here it's brown. This 'brown' vegetable is served with the obligatory boiled or fried potatoes, *Kasseler* (lightly smoked pork loin), sausages in brine and *Pinkel*. The latter is a sausage made of bacon, pork meal, beef tallow, lard, onions, salt and paper and various other spices.

The brown cabbage philosophy is a regional cult, indulged throughout the land in the legendary *Kohl- und Pinkelfahrten* that take place between November and February. On these walking trips entire clubs, societies, companies and groups of friends set off for a traditional country pub somewhere, passing the time along the way with a number of silly games, such as "tossing the teabag" and the like ...

Another hearty meal that is very popular up north is *Knipp*. This is also a type of sausage, made of oatmeal, pig's head, belly pork, rind, beef liver and stock. It may sound like poor man's fare but in the Bremen region you're a chef of the highest order if you can make good *Knipp*. Related to *Pinkel*, this pork meal sausage is served with black bread or with boiled or fried potatoes and gherkins, pumpkin, apple sauce and beetroot.

Labskaus (lobscouse or scouse) is another Bremen delicacy which you can find not only in North Germany but also in Scandinavia and Greater Liverpool in England. In the Bremen version pork or beef is mashed with potatoes in a pan and served with rollmops, fried egg, gherkins and beetroot.

Smelt, chicken hotpot and *Pluckte Finken*

Bremen smelt is one of the area's more expensive specialities. Only in spring can these tiny fish be caught in the Weser as they migrate upstream. They are coated and fried in rye breadcrumbs and have a very characteristic smell: that of fresh cucumbers!

Poultry is also found in the kitchens of Bremen. One dish is a ragout made of young chickens that weigh 200 to 600 grams (about half a pound to a pound) and are not older than one month. *Kükenragout*, to give it its German name, is a posh hotpot spiced up with crayfish, shrimp and beef tongue. Veal meatballs, asparagus or salsify, peas, mushrooms, leek and onion can also be included. Another thick broth once favoured by the seafaring fraternity is *Pluckte Finken*, based on white beans, bacon, carrots and apples.

The people of Bremen also like their sweets. One popular candy is *Bremer Babbeler*, a stick of rock containing menthol or peppermint. *Babbeler* was created by confectioner Albert Friedrich Bruns in 1886. It is mostly sold at the Bremer Freimarkt fair but can be purchased at other times of the year from chemists, drugstores, kiosks, health food outlets and select teashops dotted about the city.

Bremer Klaben is a seasonal cake for Christmas and winter, often baked in such great quantities that it lasts until Easter! *Klaben* is a heavy fruit loaf, consisting of sultanas and/or raisins, wheat flour, butter, sugar, candied peel, almonds, rum, yeast, salt and grated lemon rind. Cardamom is one of the spices used. As opposed to its German cousin the *Stollen*, *Klaben* is neither buttered nor dusted with icing sugar.

Other Bremen specialities include *Wickelkuchen* (a type of Swiss roll), hexagonal *Bremer Zwieback* (rusks), *Bremer Kluten* (sticks of peppermint half covered in chocolate), *Bremer Kaffeebrot* (butter rusks with cinnamon) and a stew made of pears, beans and bacon.

Left:
The local star of Bremen's beers is Haake-Beck pilsner. There's also a football version sold as Haake-Beck 12 or, to quote the brewery, "the beer by fans for fans".

Far left:
After the Werder Bremen football team Beck's Bier is the most famous export from Bremen. The green bottles are shipped out to over 100 countries of the world.

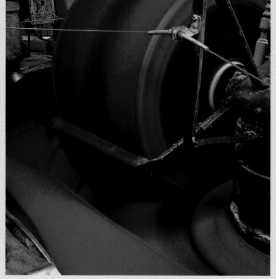

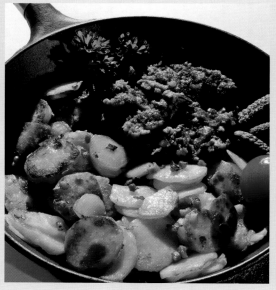

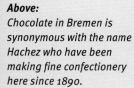
Above:
Chocolate in Bremen is synonymous with the name Hachez who have been making fine confectionery here since 1890.

Top right:
This blender at the Hachez chocolate factory finely grinds the cocoa beans. Just how often this process is performed is a trade secret.

Centre Right:
Smelt tossed in rye breadcrumbs and fried are another authentic local dish. The tiny fish are caught as they swim upriver in spring. Once poor man's fare, smelt are now a rare delicacy.

Right:
One Bremen speciality is Knipp with fried potatoes. It may look simple, but preparing this dish is an art in itself!

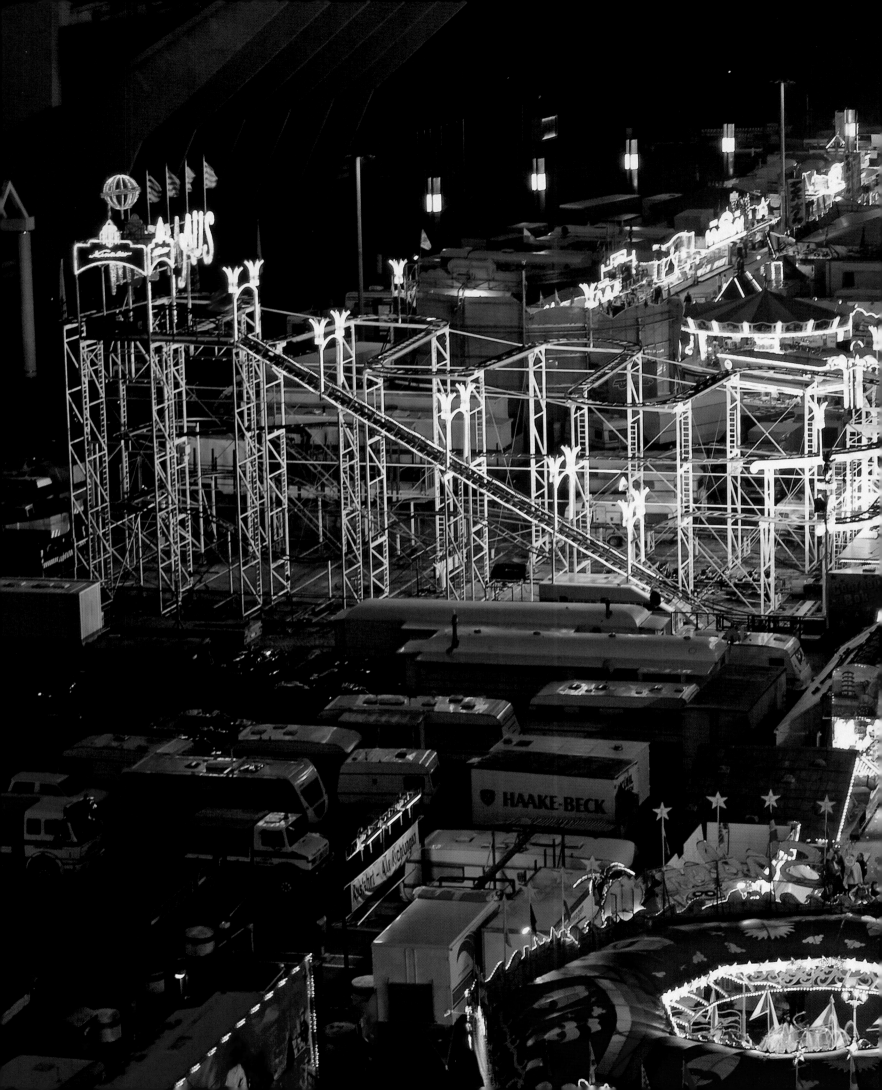

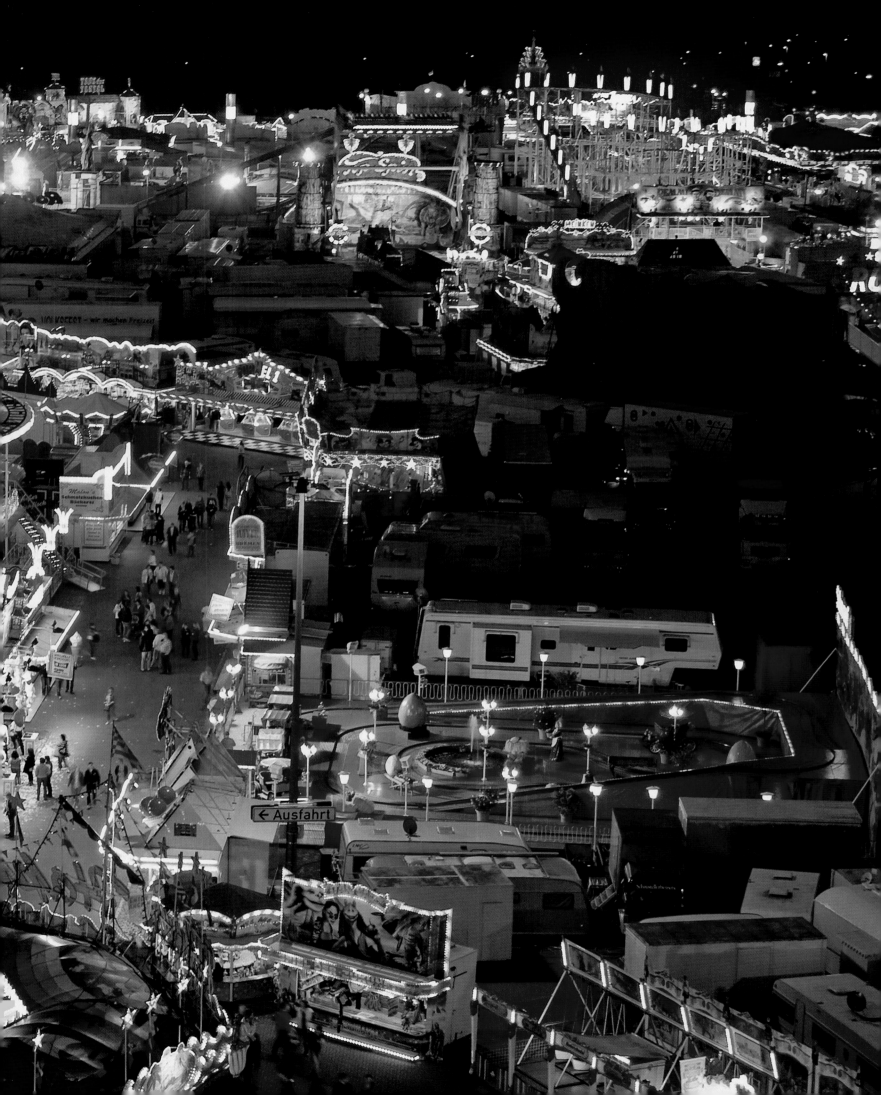

Page 82/83:
In autumn everything in Bremen stops for all the fun of the fair when on Bürgerweide and in the city the rides and side-shows of the Freimarkt are set up and the fragrance of delicious snacks wafts through the air. The festival was first held in 1035, making it one of the oldest in Germany.

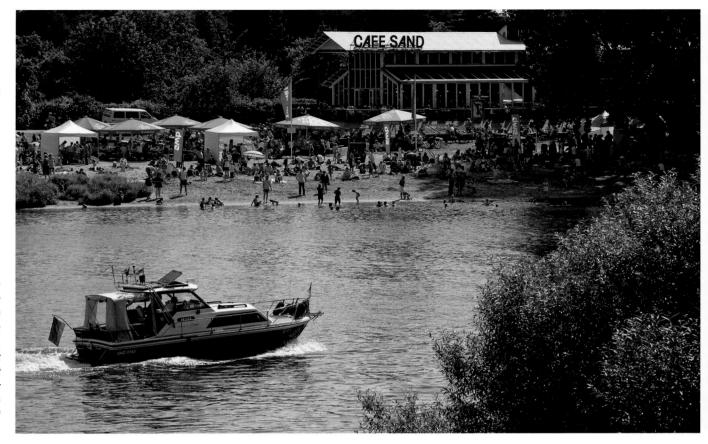

Above:
The people of Bremen love their city not least because it provides so many leisure opportunities. The Weser, for example, is not just used commercially but also for a number of water sports. Café Sand on the left bank is another local hot spot.

Right:
Thousands flock to the River Weser in summer, particularly to the Oster-deich and Café Sand. From April to October you can cross the river by cable ferry, known locally as the Ostertor.

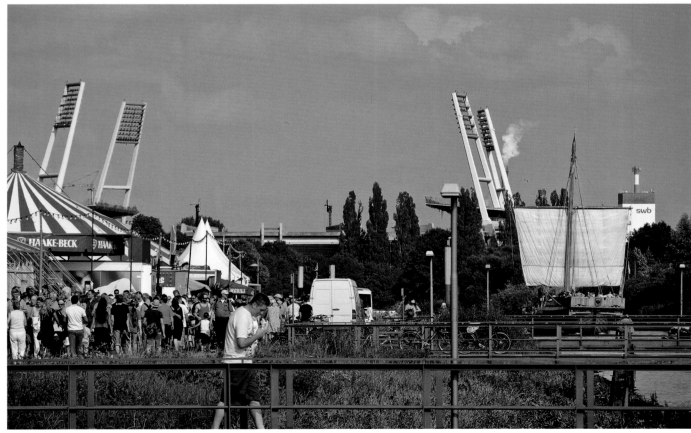

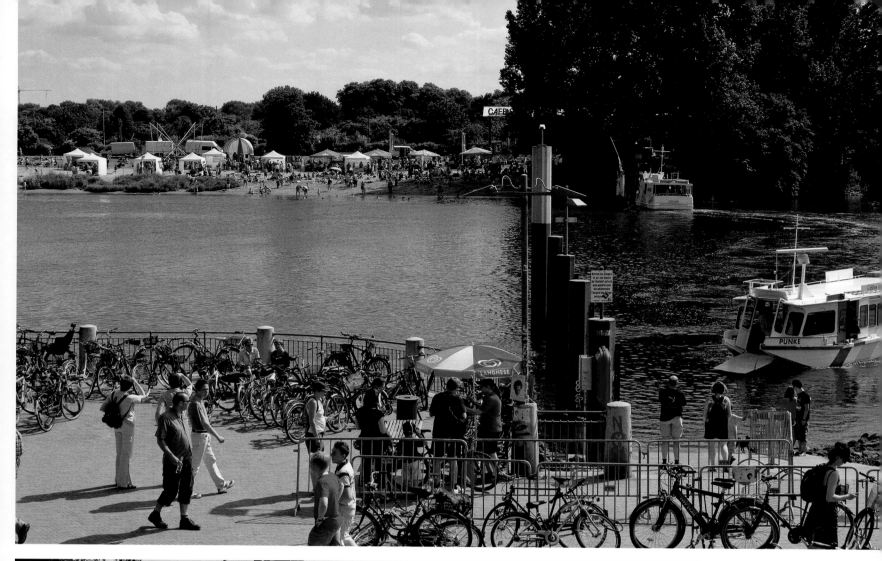

Above:
Music is exploring new avenues in Bremen – such as here at the Breminale, the mega event on the banks of the Weser. The organisers put on a huge show for the over 200,000 visitors who attend every year, with blues to wave to electronic music spilling out across the festival area between the Weser bridges and the stadium.

Left:
One of the most scenic sports stadiums in Germany is surely the Weserstadion in Bremen. Situated on the river, it's built on an earth mound or a "Werder".

Up until the late 1950s peat barges were a common sight between Worpswede and Bremen. Many city-dwellers used the peat cut from the Teufelsmoor to heat their homes, with the fuel brought to Bremen by water along the Wümme and Hamme.

What or where exactly are the environs of Bremen? There are differing opinions. People who live in the city itself list the neighbouring bits of Lower Saxony and the three suburbs north of the River Lesum here, also known as Bremen-Nord. This doesn't exactly meet with approval from the locals but the others are in the majority. This also makes the surrounding area far more diverse.

The environs of Bremen are a mixture of the urban and the rural. Where five minutes ago you were in the middle of town, now you're suddenly out in the fields and forests. In the south the ancient river valley of the Wümme curls its way along to the generous slopes of the Bremer Schweiz to the north and northeast.

To the north of Bremen is the River Lesum formed by the Hamme and Wümme rivers which peacefully winds through damp marshland. Along its left banks Bremen is rural, with palatial villas and Knoops Park to the right. The river flows into the Weser at Vegesack, a site of great historic interest. This is where you can find the oldest man-made harbour in Germany, with the first ships moored here as long ago as in 1623.

On its other shore the Weser positively dominates the countryside. The area from Delmenhorst to Bremerhaven is known as the Stedinger Land or Wesermarsch. With very few exceptions you can admire the scenery here from the dike that traces the west bank of the river. Before setting off it's worth taking a short detour to Hasenbüren to gaze upon the harbour area from the far side of the Weser.

Altenesch, Lemwerder, Berne, Elsfleth, then Brake and Nordenham: remnants of maritime history can be found in all of these places. At Nordenham your journey along the left bank of the Weser ends and you can board the ferry for the busy port of Bremerhaven.

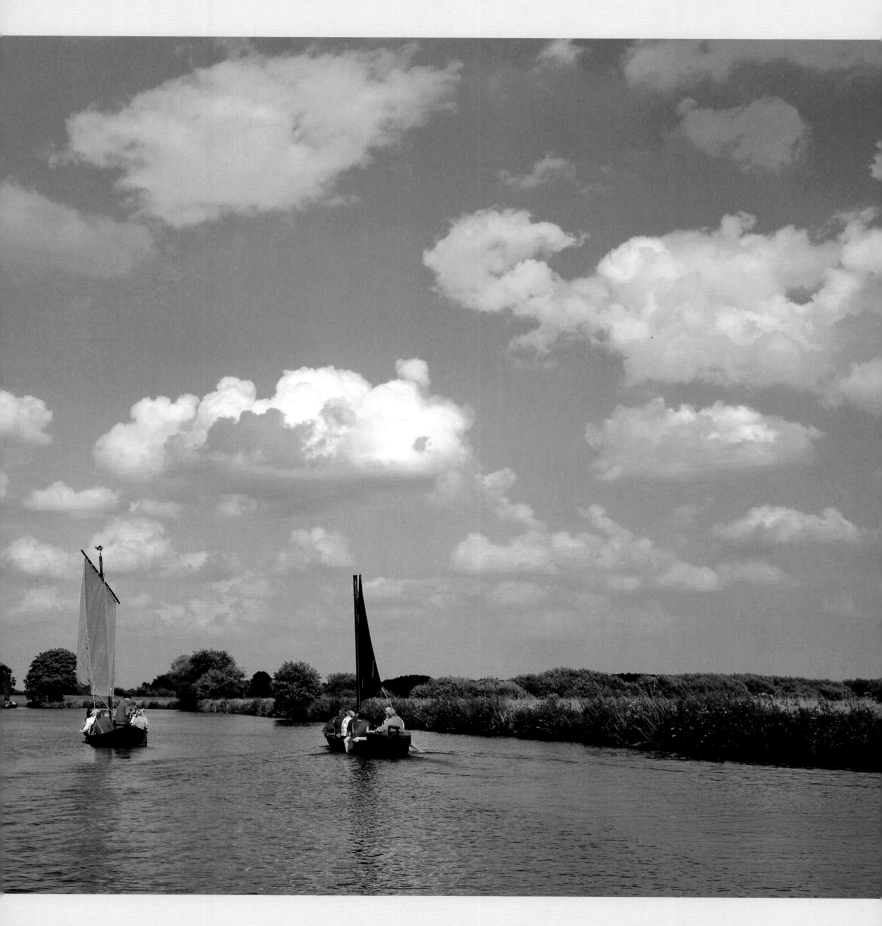

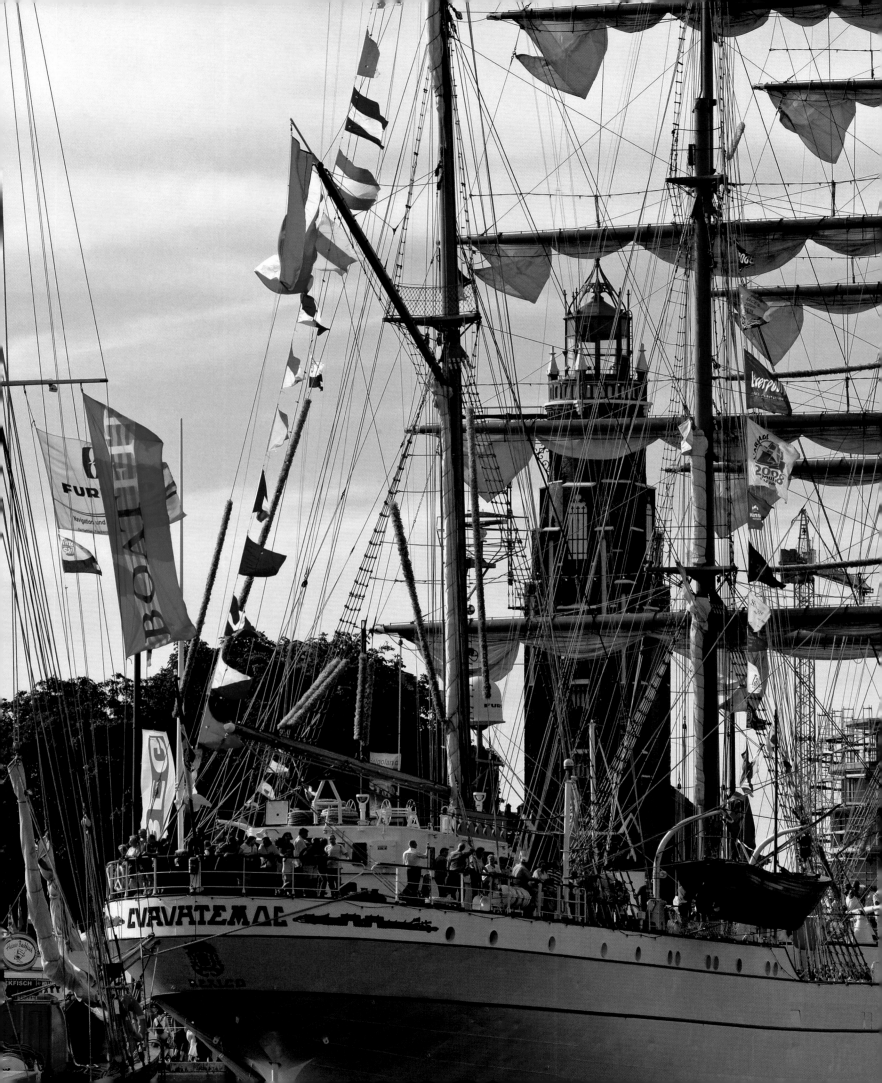

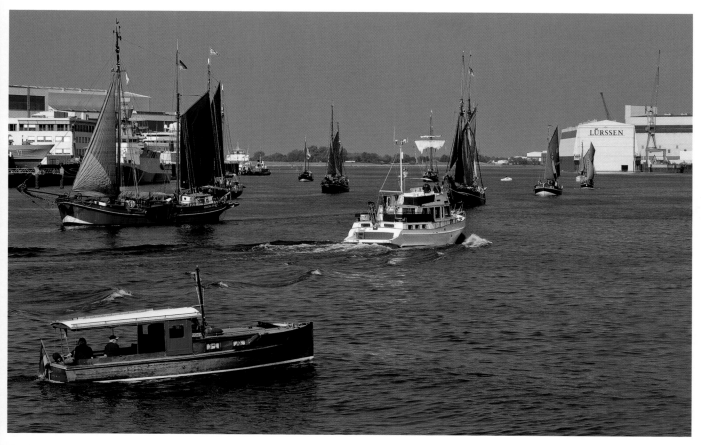

Left page:
Every few years historic ships of all shapes and sizes congregate in Bremerhaven for Sail where they are on show at the Open Ship exhibition on Neuer Hafen or run trips around the Outer Weser. Bremerhaven's Sail attracts hundreds of thousands of visitors. At the last event tall ship ARM Cuauhtémoc from Mexico, shown here, was a special guest.

The suburb of Vegesack shows Bremen at its most maritime. The harbour is the oldest man-made port in Europe and for several years now has had museum status. Many traditional ships that sail the Weser in the summer months like to dock here.

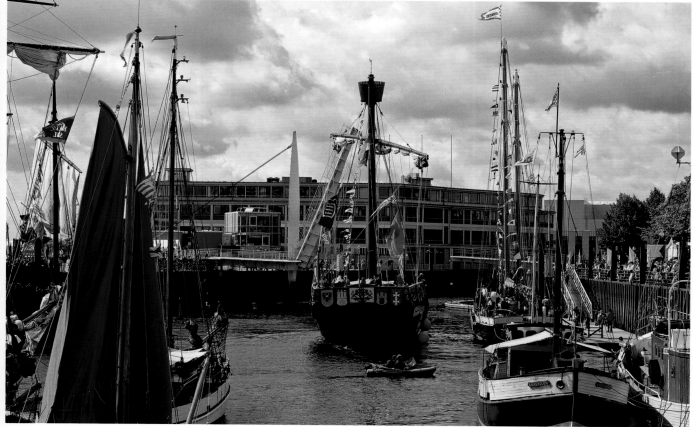

Where traditional ships are now harboured in Vegesack, Germany's fleet of herring luggers was moored – until the end of the 1960s. The harbour was built between 1619 and 1623 as the Weser kept silting up, threatening trade with Bremen. The photo shows the replica Hansa cog Ubena von Bremen leaving port.

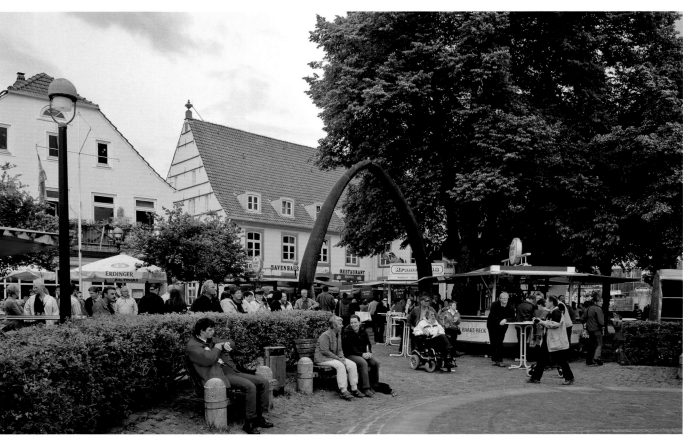

Right:
One popular meeting place in Vegesack is Utkiek or lookout, to give it its English translation. This square was where captains housed in the Havenhaus in the background (right) would keep watch for their ships. The Vegesack whalebone arch is also famous, reminiscent of the days when whaling was once big business in the then autonomous town. The lower jaw of a blue whale that marks the entrance to the square was once donated to Vegesack by a successful whaler and replaced by a bronze copy in the 1990s.

Right page:
Not only ship's captains but also well-to-do shipowners and shipyard proprietors had fine homes erected on the banks of the Weser near Vegesack. Some are akin to small castles, from the turrets of which their inhabitants could gaze out across the river onto the Stedinger Land.

Right:
Weserstraße is lined with splendid housing once inhabited by seafaring captains and their families. These grand edifices date back to the time when the profits of transported goods were shared, guaranteeing a good income.

Far right:
This statue in the gardens of Haus Seefahrt in the suburb of Grohn is named Brema after the Latin for Bremen.

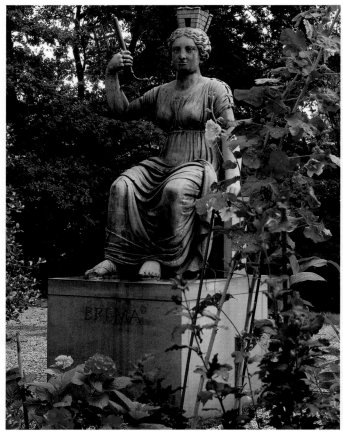

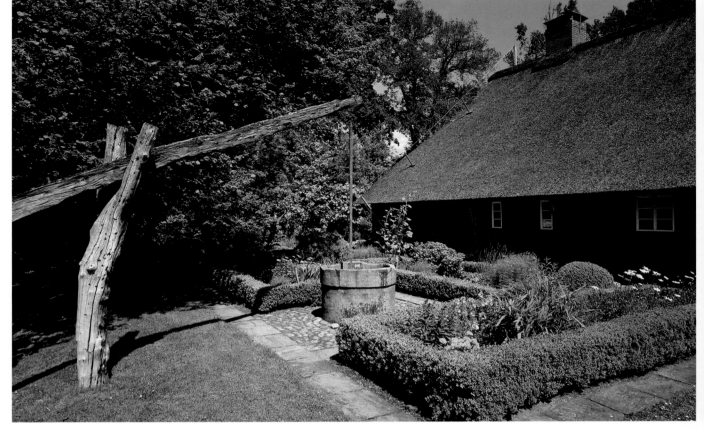

Haus Mittelsbüren, a typical Lower Saxon farmhouse, is now situated in the grounds of the Focke Museum. Until the 1950s it stood in the suburb of the same name on the Weser which was demolished to make way for the Bremen steelworks.

In winter life at Haus Mittelsbüren centred around the fireplace or Flett. Lower Saxon farmhouses had a large hall where the animals were also kept. The hay was stored on ricks. The sleeping area was at the back of the house.

Right page:
Haus Riensberg is also part of Bremen's Focke Museum. It was built in the second half of the 18th century and was the farmhouse on the Riensberg estate. It has been used by the museum since 1953 to house exhibits on life in Bremen, a collection of European glass and also a children's museum with lots of old-fashioned toys.

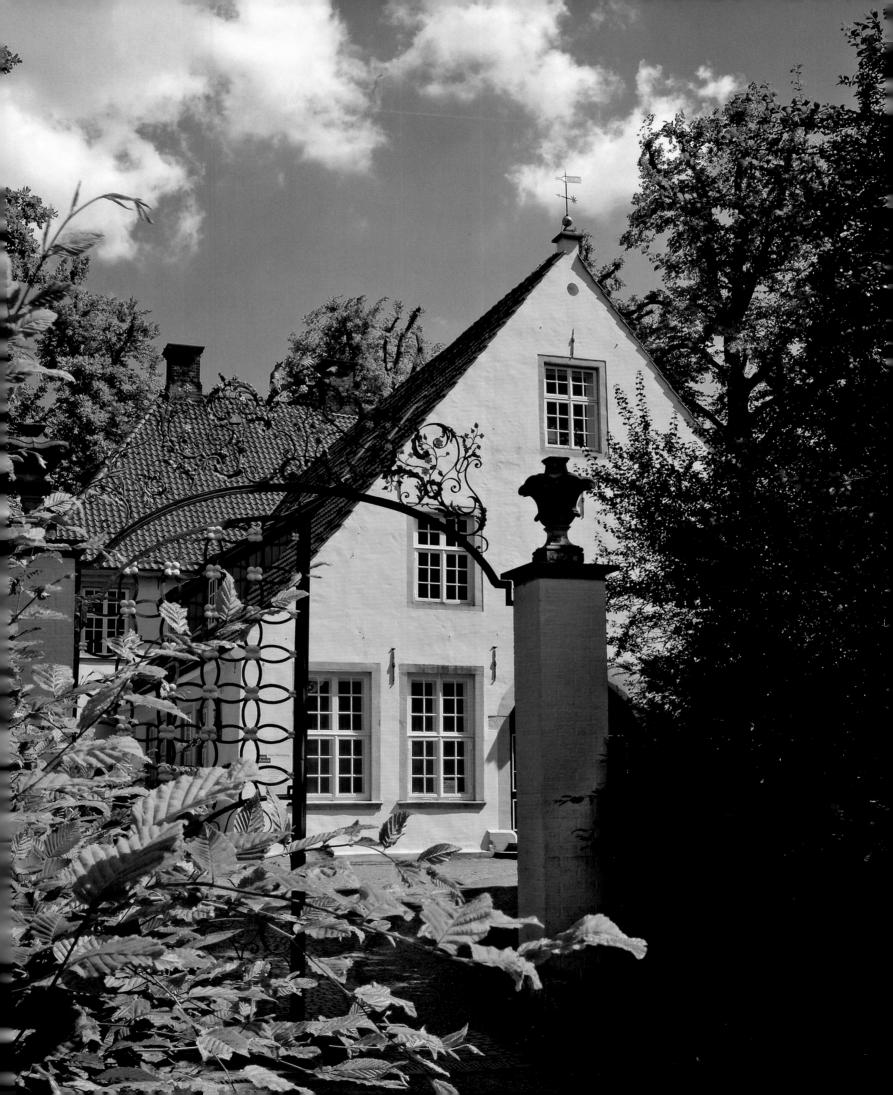

Above:
Country idyll in the heart of town: the Werderland on the River Lesum, one of Bremen's most popular country parks. Strolling along the dike you come across many remnants of the past, including this bakehouse that dates back to before Lesumbrok became a suburb of Bremen.

Right:
Pretty thatched cottages such as this one can still be found in the suburbs of Lesumbrok and Mittelsbüren. Life was hard for the smallholders who once lived in them. The houses are now no longer used as farm buildings.

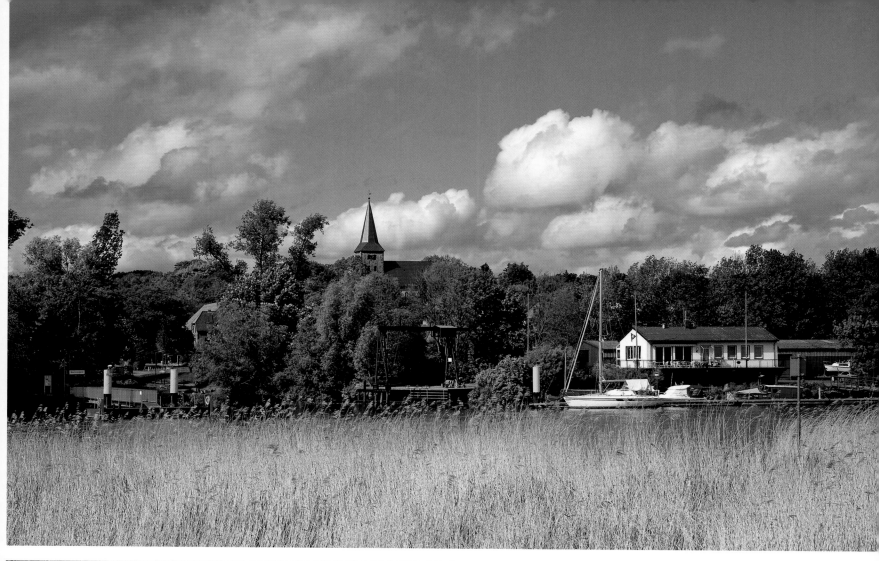

Above:
View of the Werderland and Lesum. The church of St Martin's, its steeple just visible beyond the trees, is built on a sandy hill and was first mentioned in 1235. In the foreground the River Lesum winds through marshland.

Left:
Knoops Park stretches out along the right bank of the River Lesum. It was laid out at the end of the 19th century by Bremen businessman Ludwig Knoop. Rich Bremen merchants once had their summer residences built in the grounds and around the edge of the park.

95

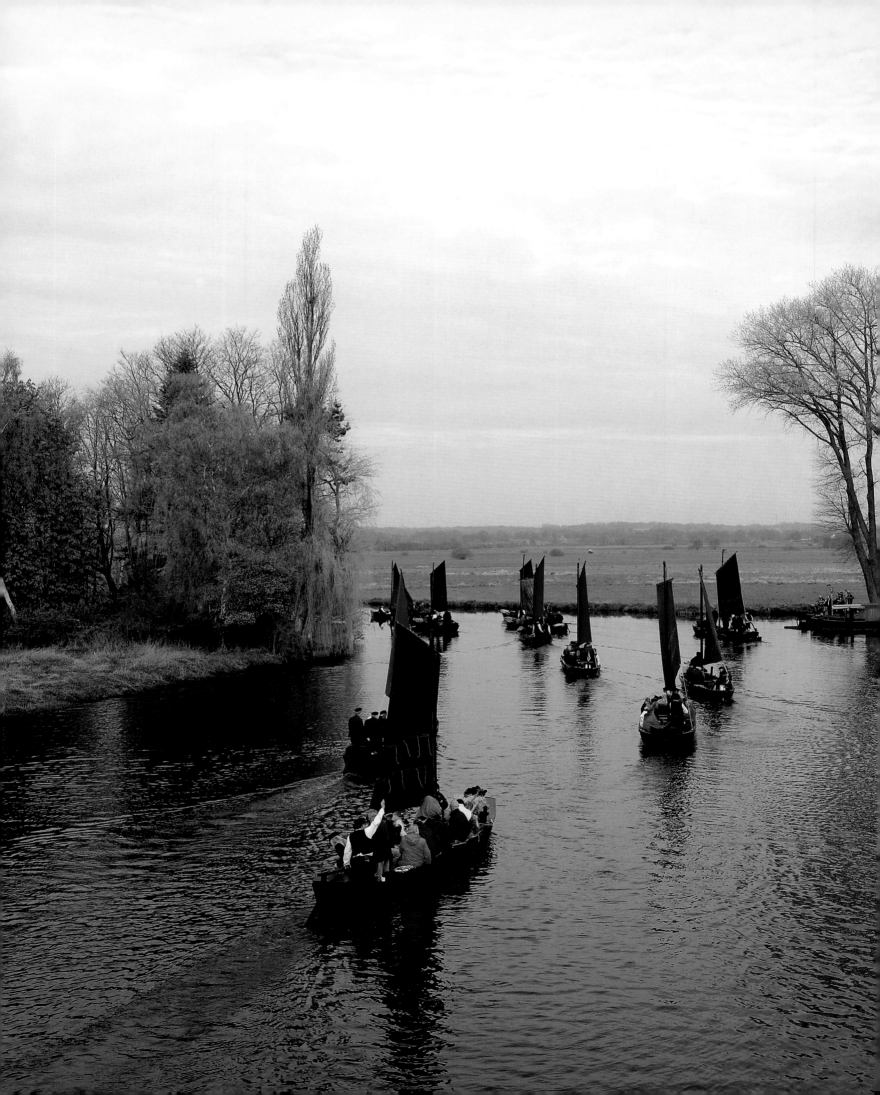

Page 96/97:
Teufelsmoor bathed in the light of dawn, seen from Tietjens Hütte looking towards Worpswede. Maybe the artists at the colony once gazed upon the same beautiful sight.

Left page:
When the peat barge season begins in spring the little boats of Osterholz and Bremen set sail along the River Hamme. The journey usually ends in Ritterhude, with some of the river craft travelling on into Bremen from May onwards.

Left:
The tourist offices of the Osterholz and Worpswede districts 'rediscovered' the commercial assets of the peat barge around ten years ago. At harvest festival the boats are still in regular service, with themed tours starting out from the Neuhelgoland mooring.

Page 100/101:
In the Barkenhoff Heinrich Vogeler created not only an artistic gem but also a suitable salon for the painters, sculptors and architects of Worpswede. The gardens are quite impressive – as is the grand staircase leading up to the main entrance. Painstakingly restored a few years ago, Barkenhoff has works by the first and second generation of the Worpswede colony on display.

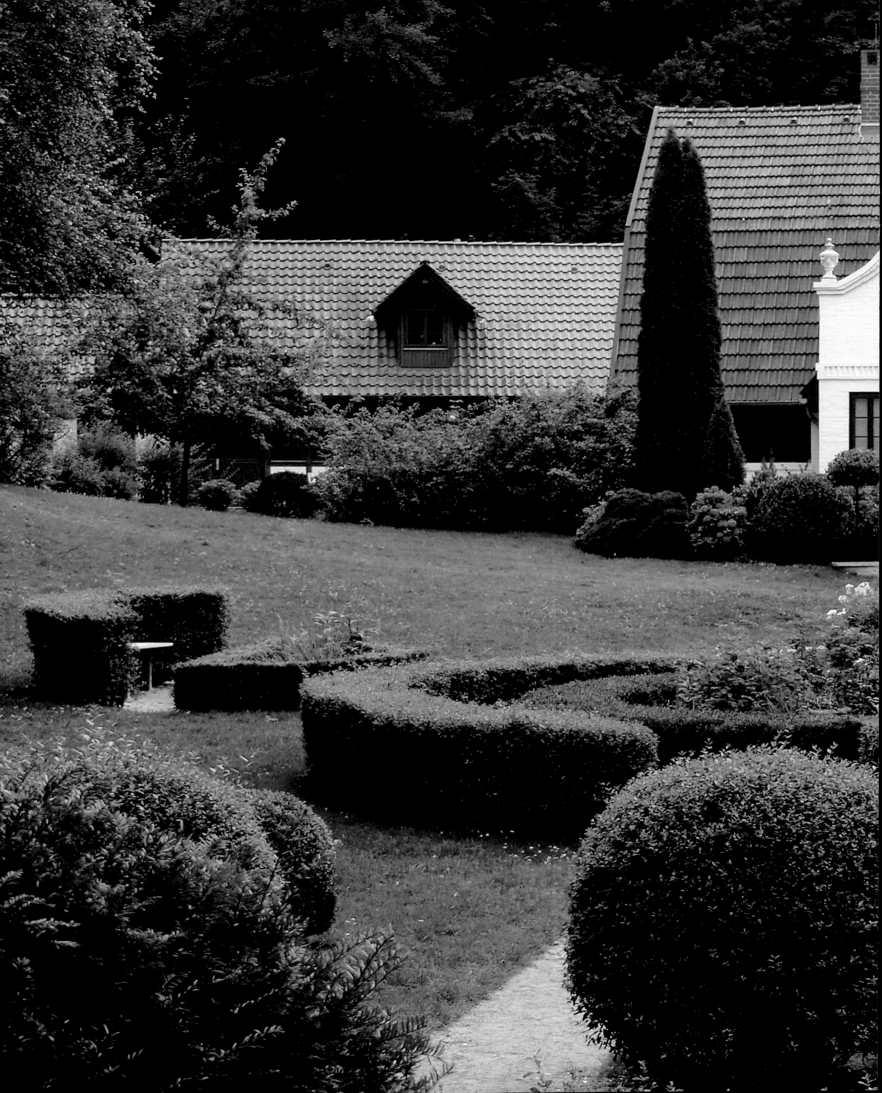

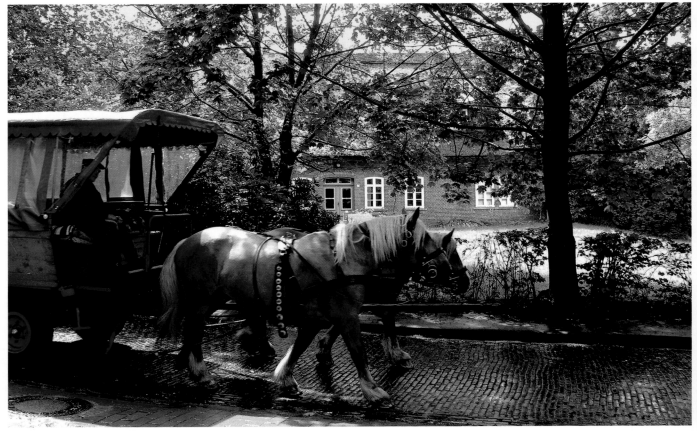

If you want to explore Worpswede, Fischerhude and the surrounding area, one good way to do so is on a horse and cart where you can paint your own imaginary picture of the moor at a sedate and relaxing pace.

This, too, is Worpswede: the thatched country cottage. It lends the village a distinctive charm and forges a link between the intimate cosiness of village life and the broader perspectives of the artist. Worpswede is still a great source of inspiration for sculptors, painters and many other creative minds.

Right page:
Haus im Schluh is a part of Worpswede attributed to the second generation of artists. Martha Vogeler, Heinrich Vogeler's wife, had the farmhouse moved from Lüningsdorf to Worpswede in 1920.

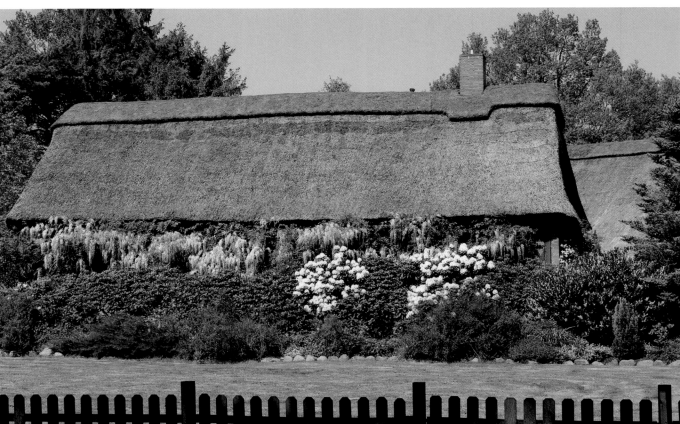

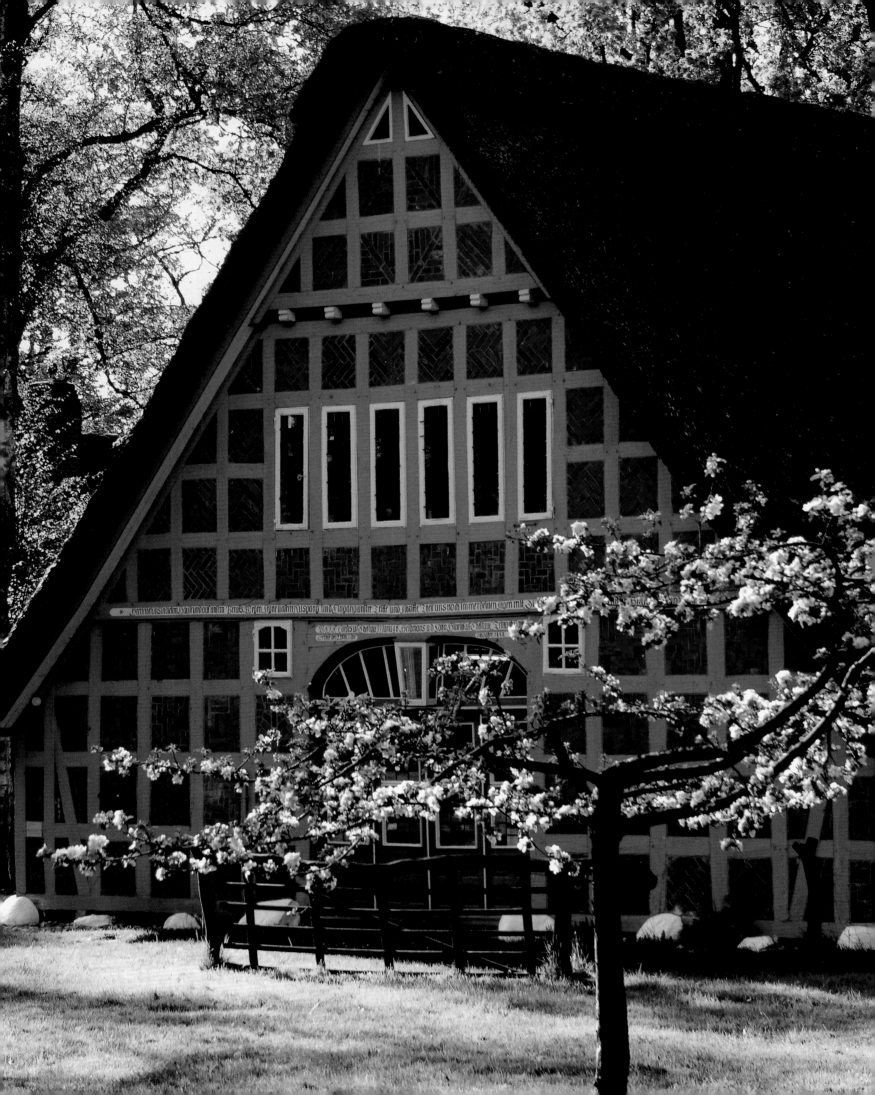

ARTISTS' COLONY ON A DEVIL'S MOOR – WORPSWEDE

It was the light that fascinated them. They also came here in search of country idyll, their view of life out in the sticks both rose coloured and romantic. About 20 kilometres / 12 miles from Bremen, Fritz Mackensen, Hans am Ende and Otto Modersohn found what they were looking for. In the little hamlet of Worpswede on Teufelsmoor the three Impressionist and Expressionist artists unpacked their bags and started painting.

What happened in Worpswede in the decades that followed has shaped the character of the village to this very day. In 1893 the first settlers were joined by Fritz Overbeck, Heinrich Vogeler and Carl Vinnen, and later by Clara Westhoff, Bernhard Hoetger, Johannes Wüsten, Rainer Maria Rilke, Otto Ubbelohde, Walter Bertelsmann and Wilhelm Scharrelmann.

Their legacy is palpable in many different ways. There are the real, tangible buildings and objects they built and created. There is also the spirit of those early years, carefully preserved in the artistic flair and culture of Teufelsmoor and in the many galleries and artists based in Worpswede today.

One way of soaking up the atmosphere of the artists' colony or finding out just how hard life on the "devil's moor" really was is to board a boat in Vegesack and travel to Neuhelgoland along the Lesum and Hamme rivers. Neuhelgoland marks the spot where local peat barges transported fuel to Bremen cut from the moor up until the 1950s.

It's not far from the mooring to the village itself. The path winds through elysian fields. Just beyond the start of the village there's a dip with a farm in it (the Music Hall) where, rather unbelievably, the greats of the rock and pop business often play. A few hundred yards further down the road on the right is the only elevation in the entire region: Weyerberg.

Strolling through Worpswede, you're sure to pass all the sights. It's best to start from the top, as it were, from the Niedersachsenstein on Weyerberg. This was fashioned in the early 1920s by architect and sculptor Bernhard Hoetger who also built Böttcherstraße in Bremen. The Niedersachsenstein is a memorial to the soldiers who fell in the First World War. Eighteen metres / almost sixty feet tall, the monument is ambivalent in its interpretation. On the one hand it's the only large-scale Expressionist sculpture in Germany. In recent years, however, historians have frequently posed the question as to what extent the Niedersachsenstein represents Hoetger's connections with nationalist circles.

Another stop en route is the Haus im Schluh at the foot of Weyerberg. This was moved from the moorland village of Lüningsee to Worpswede and rebuilt in 1920 at the instigation of Heinrich Vogeler's wife, Martha.

Barkenhoff and Kaffee Verrückt

Visitors should definitely leave enough time for the Barkenhoff, local dialect for "Birkenhof" or beech farm. It was purchased by Heinrich Vogeler who converted it into a meeting place for the arts scene that pays full homage to the fads and fashions of the Jugendstil period. The steps leading up to the main entrance are particularly impressive. Barkenhoff has many works by the first and second generation of Worpswede artists on show in a truly unique setting.

The colony of Worpswede is just as famous for the Große Kunstschau and Kaffee Worpswede at the foot of Weyerberg. The latter was conceived by Hoetger. The café is also known as Kaffee Verrückt or mad café, as Hoetger started building without any plans and didn't include a single right angle. Another of Hoetger's creations graces the car park: the statue of a laughing Buddha. And while you're here, don't forget to spend plenty of time perusing the many galleries ...

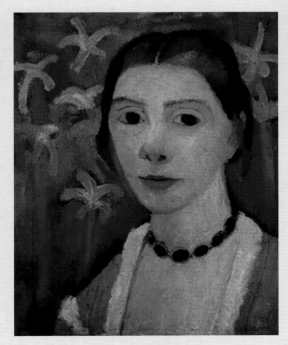

Left:
Unrecognised in her lifetime, Paula Modersohn-Becker only later received the acclaim she deserved. She is now heralded as one of the pioneers of early Expressionism.

Above:
Pure, unadulterated Expressionism greets you as soon as you enter the car park of Kaffee Verrückt and the Große Kunstschau in Worpswede. The sculptures are by Bernhard Hoetger.

Heinrich Vogeler was one of the first generation of Worpswede artists – and probably the most tragic. A convinced socialist, he went into exile in the young Soviet Union where he died in sorry circumstances at the age of 70.

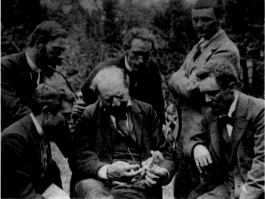

Nicola Perscheid photographed Bernhard Hoetger in c. 1924. The architect and sculptor met Paula Modersohn-Becker whilst in Paris and ended up in Worpswede after setting up three studios in Fischerhude in 1914.

Top right:
Otto Modersohn, Fritz Overbeck, Hermann Allmers, Fritz Mackensen, Heinrich Vogeler and Carl Vinnen met in Worpswede in 1895. Hermann Allmers

lived and worked in Rechtenfleth, a small village halfway between Bremen and Bremerhaven. He was, however, a frequent guest in Worpswede.

Right:
Bernhard Hoetger is famous not just for his "mad café" and the Niedersachsenstein but also for this sculpture "the dreamer".

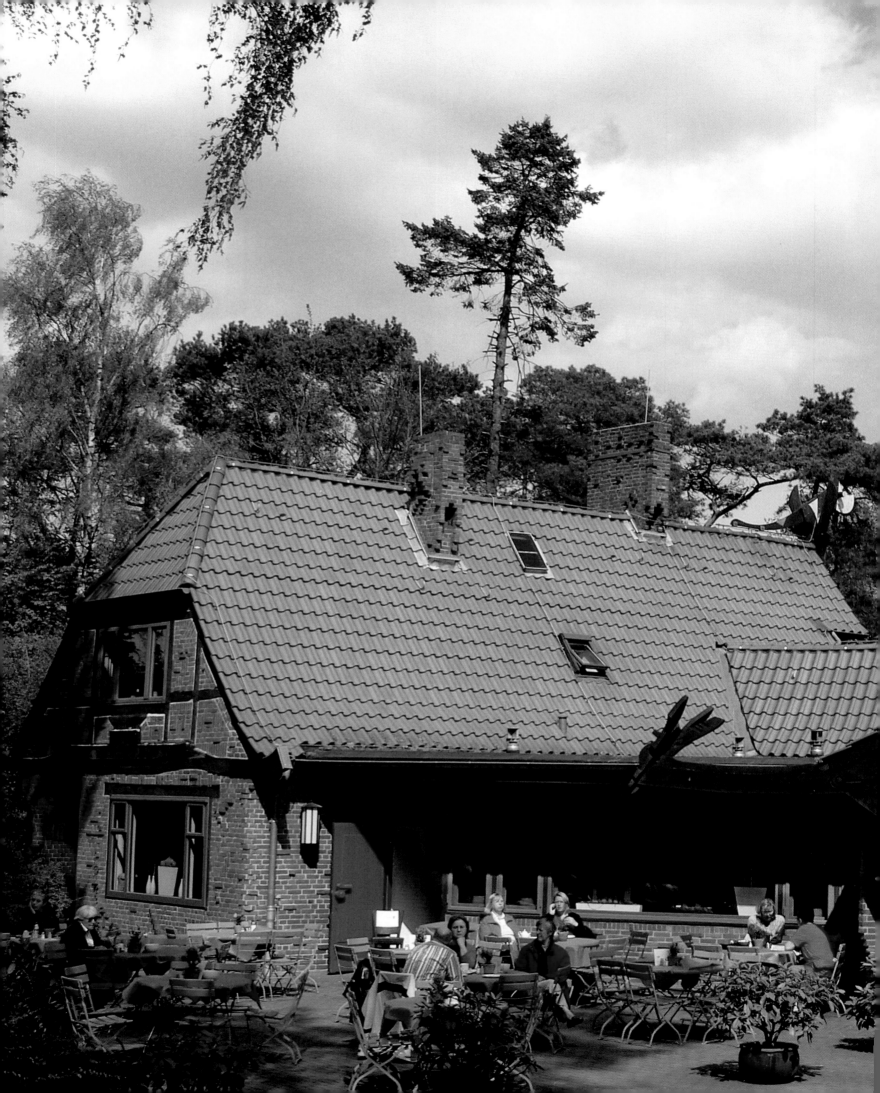

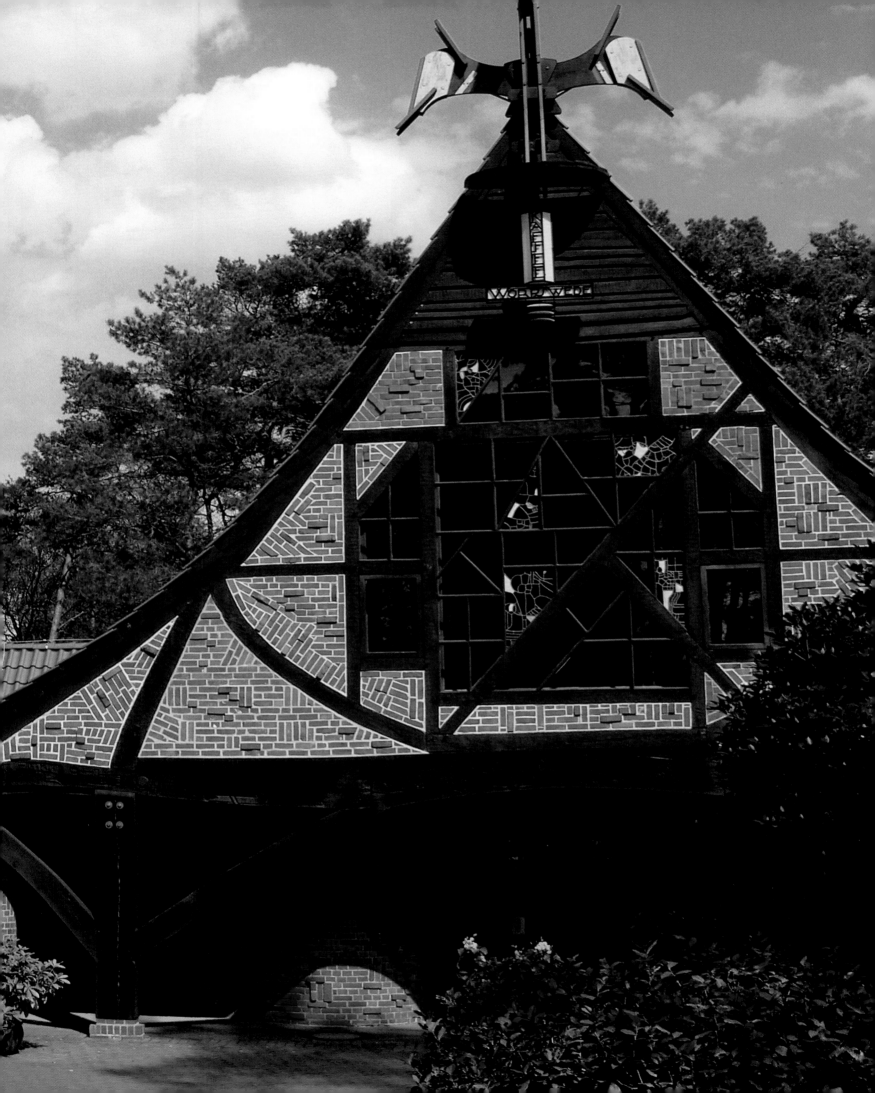

Page 106/107:
Kaffee Verrückt, or Kaffee Worpswede, to give its proper title, is the work of architect Bernhard Hoetger. The building is especially unusual in that it has no right angles.

The huge Niedersachsenstein, again by Bernhard Hoetger, was built to commemorate the dead of the First World War. It stands atop the Weyerberg and is the only large-scale Expressionist sculpture in Germany.

Haus im Schluh not only has art exhibitions and collected works on show in two of its three thatched buildings but also a lovely garden.

Right page:
In spring and autumn the River Hamme often bursts its banks between Osterholz-Scharmbeck and Worpswede. In the background you can just make out the mound of the Weyerberg.

Page 110/111:
Ancient trees provide welcome shade on the paths in and around Worpswede, adding to the general sense of country idyll.

A relaxing cup of tea or coffee in the café garden also wouldn't go amiss ...

This seating area in one of the village gardens simply cries out for you to sit down and unwind after your tour of the galleries!

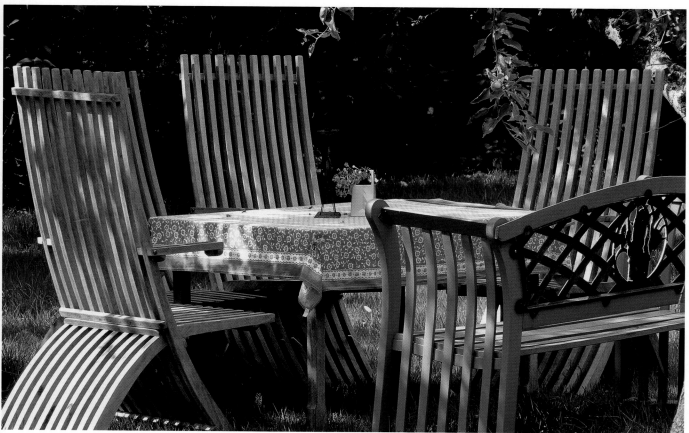

Left page:
Worpswede is not just art. Its gardens are also worth visiting, even if just to mull over the many beautiful things you have seen in the colony's galleries and studios.

Artists' colony on the Wümme – Fischerhude

We cannot fully understand the development of Worpswede without taking a look at a small village on the River Wümme: Fischerhude. Like Worpswede, Fischerhude was also an artists' colony that flourished under the auspices of Otto Modersohn, among others. At the turn of the 19th century the artist moved to Fischerhude where his work is now on display at the local museum, among various other places. The tiny colony was begun on the initiative of Heinrich Breling and Wilhelm Heinrich Rohmeyer in 1908.

Breling rose to fame as a genre and historical painter and was later revered for his Impressionist art. The artist was born in Fischerhude in 1849 and studied art in Hannover. He was made professor at the academy of fine arts in Hannover in 1883 and a year later royal artist to King Ludwig II of Bavaria. On his decision to return to North Germany Breling had a new studio built alongside the babbling brook of Bredenau that was to form a nucleus for the new artists' colony.

Otto Modersohn wasn't the only one to follow the pioneer to Fischerhude. Rainer Maria Rilke's wife, Clara Rilke-Westhoff, and her brother Helmuth Westhoff, as well as composer Karl Gerstberger and writer Diedrich Speckmann also brought fame to Fischerhude, part of Ottersberg since the district reform of Lower Saxony in 1972.

Clara Rilke-Westhoff was heralded as one of the best female painters and sculptors of her day. She was born in Oberneuland in Bremen in November 1878 to businessman Heinrich Westhoff. She died in Fischerhude in 1954. Rilke-Westhoff first took private art lessons in Munich. In 1898 she continued her studies in Worpswede, sketching and modelling under Fritz Mackensen. She was thus introduced to the creative circles of Worpswede – and at Barkenhoff she met the man who was later to become her husband, Rainer Maria Rilke. A daughter was born but the marriage failed and in 1919 Clara moved to Fischerhude.

In many ways Rilke-Westhoff followed in her brother's footsteps. Painter Helmuth Westhoff settled in Fischerhude in 1918, having before become a pupil of Carl Weidemeyer in Worpswede in 1906. Wiedemeyer already belonged to the second generation of colony artists. Westhoff also studied under Otto Modersohn and also in Munich, Paris and Berlin.

The heath poet

Admired in Fischerhude but also not uncontroversial due to his declared belief in National Socialism, Diedrich Speckmann was a well-known local writer. He was born to a missionary in Hermannsburg near Ganderkesee, studied theology, first worked as a governor and then as a parson in Grasberg from 1902 to 1908. Health problems then caused him to change his profession from pastor to poet. His best-known works from the first half of the 20th century include *Die Heideklause, Jan Murken, Das Anerbe* and *Heidehof Lohe*. Heidemann also served as a soldier in the Belgian communications zone between 1915 and 1918. He wrote down his experiences in a diary which was only published in 2005.

Writers, painters and many other interesting people have given the little village of Fischerhude its unmistakeable flair, one appreciated by many an art enthusiast. Its artistic spirit can be sensed at every turn: in its narrow streets, on the main drag between Ottersberg and the surrounding villages, even on the banks of the Wümme and along the shady paths that wind through its fields and meadows. To really get a feel for the place you'd be well advised to leave your car behind and hire a bicycle. Along the Wümme cycle track, past the university and the suburb of Borgfeld, Fischerhude can be reached from the centre of Bremen in a good two hours.

Left:
This is how artist Paula Modersohn-Becker saw her colleague and friend Clara Rilke-Westhoff in 1905.

Above:
Gem on the Wümme: these houses are typical of the artists' village of Fischerhude.

Top right:
This self-portrait of
Heinrich Breling was
painted in 1914, the
year of his death.

Centre right:
The beautiful countryside
of Fischerhude inspired
August Haake to paint "An
der Wümme" in 1912.

Right:
In c. 1920 Wilhelm
Heinrich Rohmeyer
painted "Kuhtrift". He was
responsible for starting
the Kunstschau or art
display in Fischerhude.

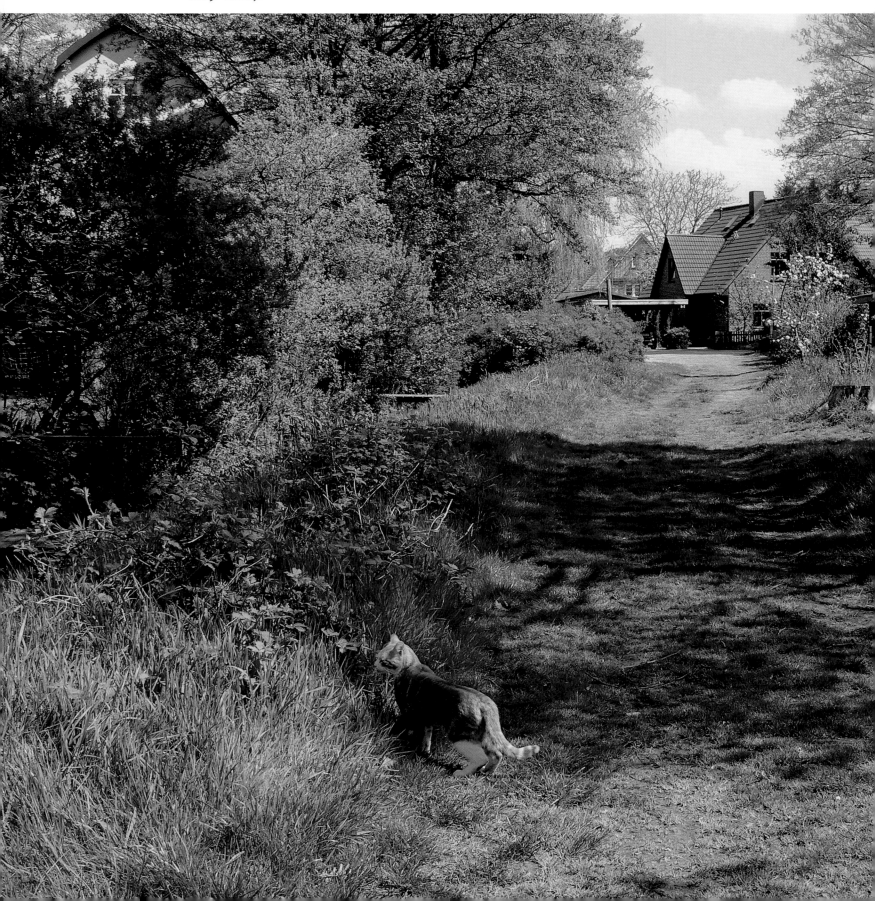

Below:
Off the beaten track Fischerhude looks much like it did at the end of the 19th century.

Top right:
Blossom in Fischerhude. The beauty of the countryside makes it easy to understand why so many artists have been moved to come and work here.

Centre right:
In and around Fischerhude there are plenty of opportunities to explore the halcyon valley of the Wümme on a pony and trap.

Bottom right:
Fischerhude is effused with artistic flair and creativity, right down to the design of many of the wonderful gardens here.

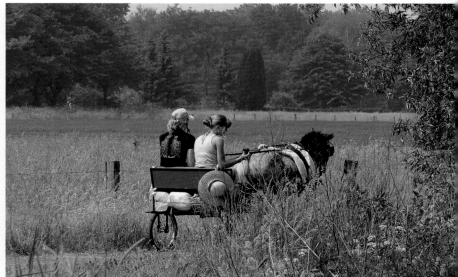

The countryside near Worpswede is extremely scenic, prompting many to settle here and draw inspiration for their unique works of art.

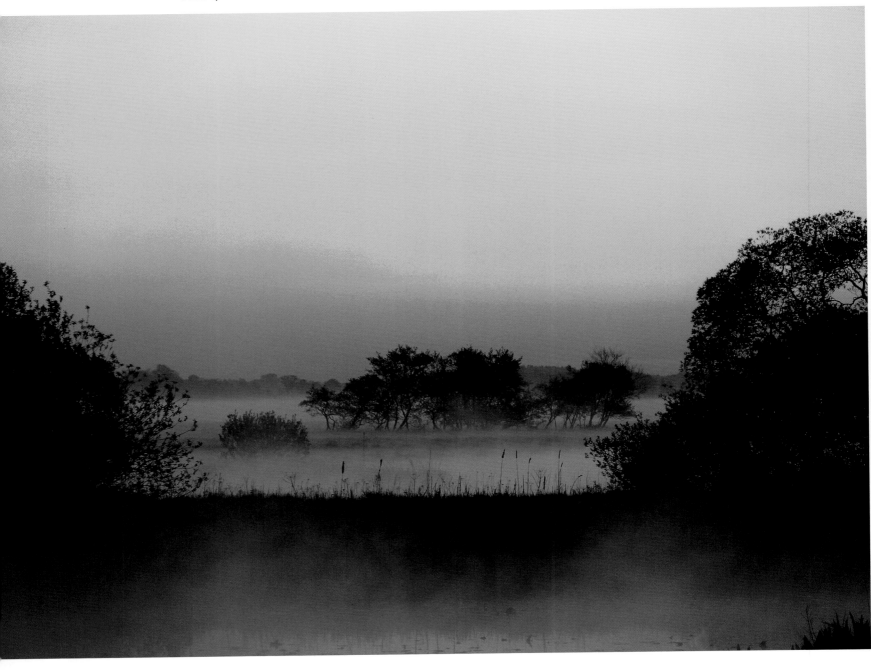

Like in a watercolour morning fog shrouds the soft pastels of the fields and skies around Worpswede, with the sharp black outline of the trees providing a bold contrast.

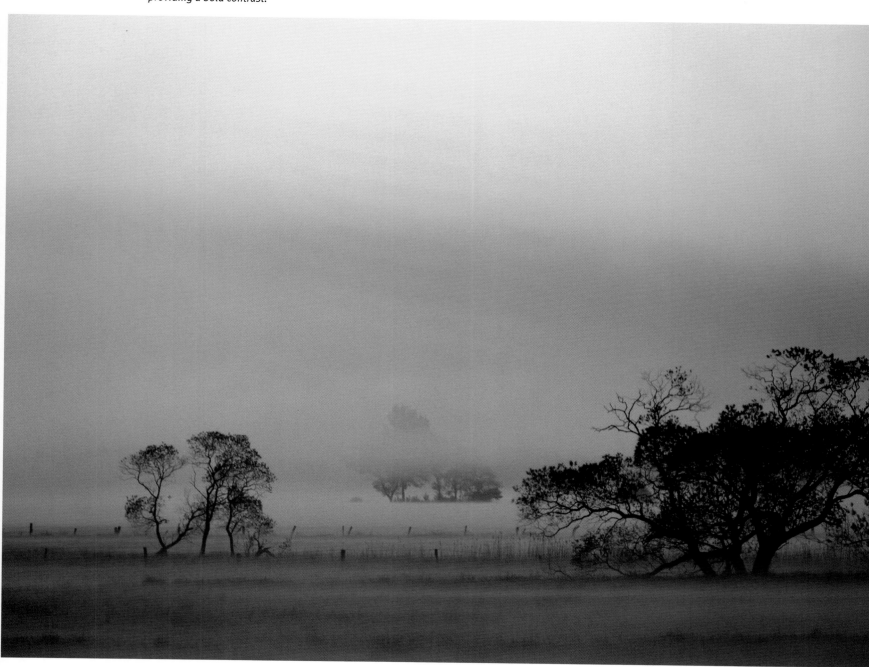

Harbouring history in Bremerhaven

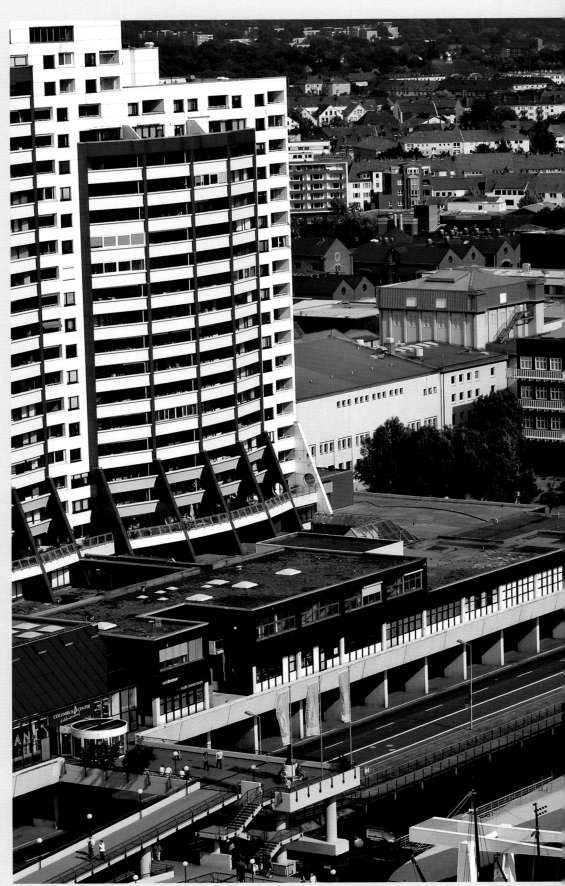

Bremerhaven seen from the Atlantic Hotel. The city was founded by Bremen on Alter Hafen in 1827, where the ships of the German Museum of Shipping can now be explored. The old port also has the new Columbus Centre (left) and the internationally renowned Alfred Wegener Institute for Polar and Marine Research (centre).

The skyline is impressive: ocean liners and container loading bays on the left, then the Atlantic Hotel shaped like a sail, the unusual Klimahaus and the twin skyscrapers of the Columbus Centre. All of the above are part of Havenwelten, which together with the zoo, the Deutsches Auswandererhaus (museum of emigration) and the German Museum of Shipping make up the new maritime tourist centre in Bremerhaven, the second city in the smallest federal state in Germany.

The latest hit is the Klimahaus where visitors trace the 8th degree of longitude to discover how our climate changes around the world. Here your journey takes you from Bremerhaven to the Swiss Alps, then on to Nigeria, the Cameroons and the Antarctic, to Samoa and Alaska and finally back to Bremerhaven.

Bremerhaven's history goes back to the 19th century when Bremen bought a strip of land from the kingdom of Hannover for exactly 73,658 Thaler, 17 groschen and 1 penny. The plot north of the Geeste Estuary was to be turned into a new harbour as the Weser in Bremen was gradually silting up. After several changes of hands Bremerhaven and its once autonomous suburbs fell permanently to Bremen in 1947.

Bremerhaven owes much of its past livelihood to fish and where better to study this than at the Schaufenster Fischereihafen, the fishing harbour. The market where cod, flounder and other fruits of the sea were once auctioned is now one of the city's most popular venues where you can come and watch the maritime economy at work, try the local produce or just soak up the atmosphere.

It's also worth going to see the container terminal, easily reached from Havenwelten. You can't actually get into the harbour but there is a visitors' platform providing breathtaking views of the entire area and the shipyards. If you want to find out even more about Bremerhaven and its harbour history, just hop on a boat for a tour of the port.

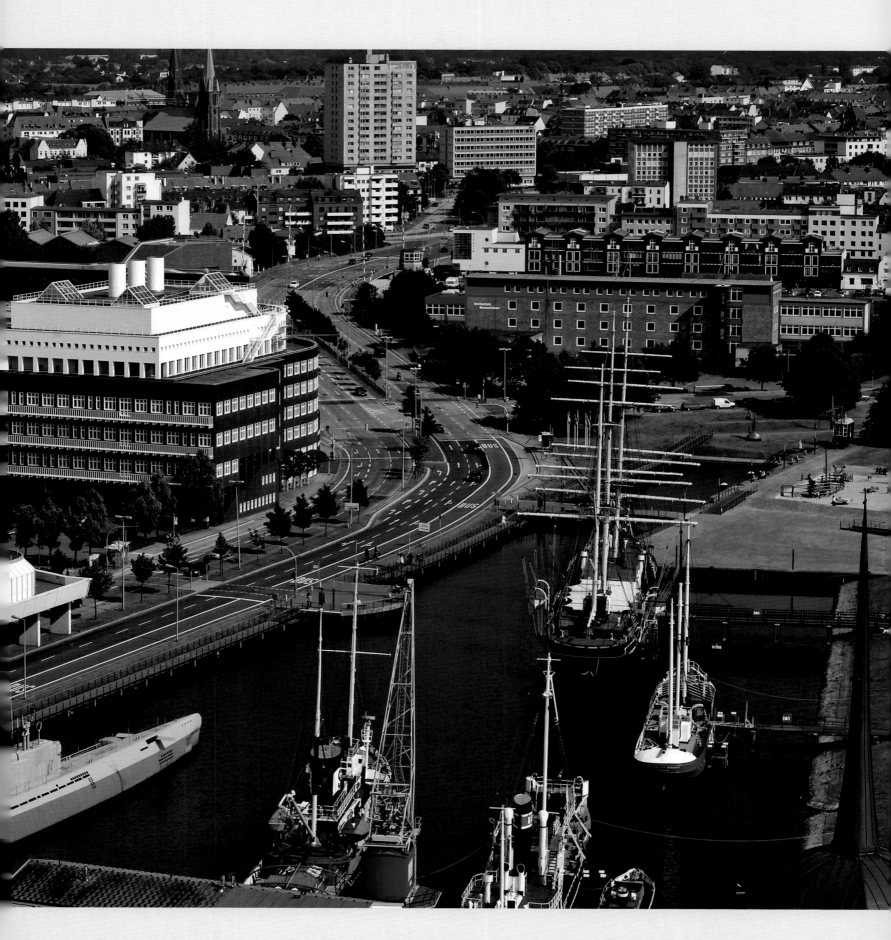

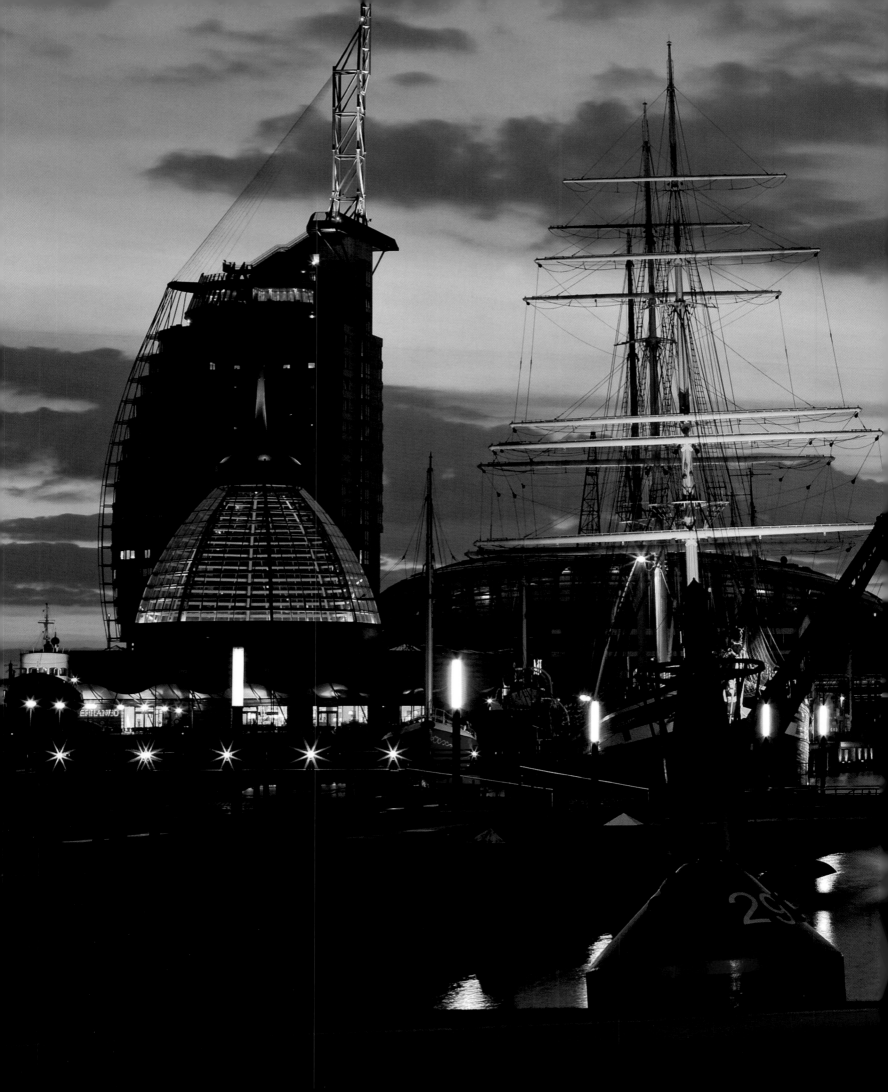

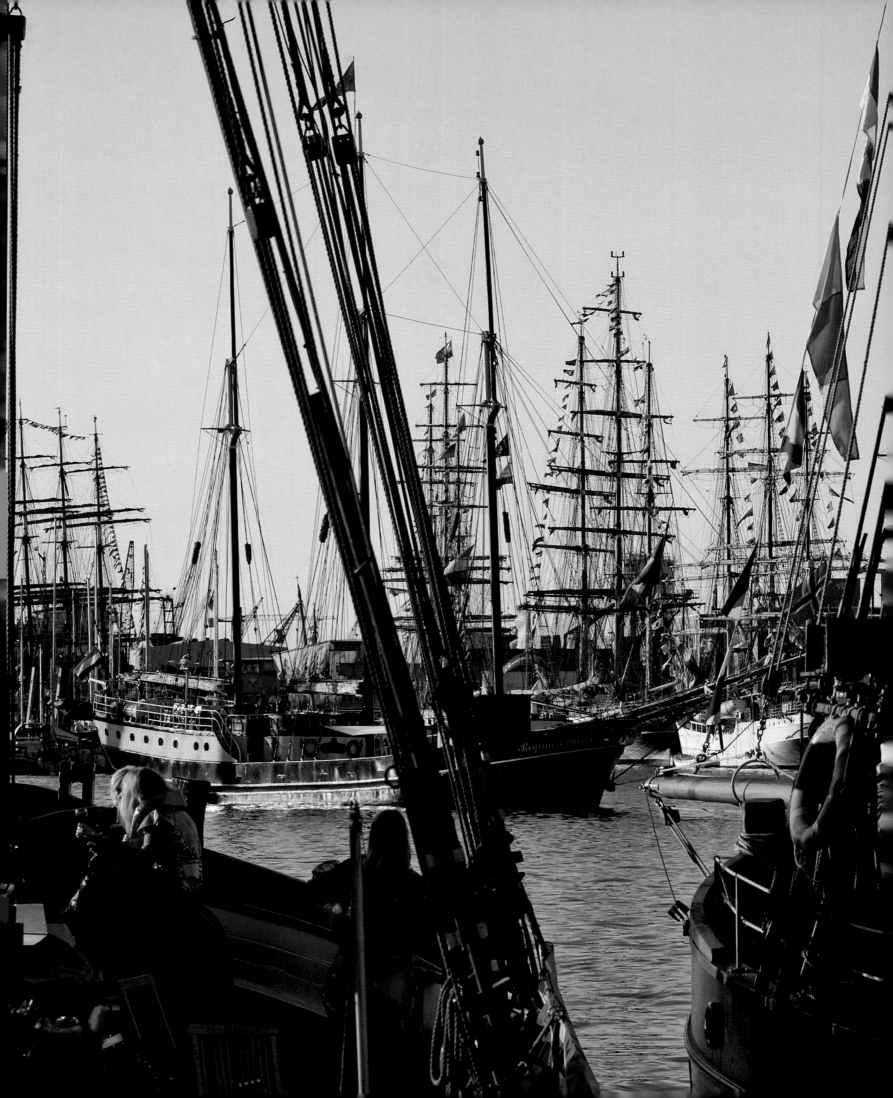

Page 122/123:
Bremerhaven at dusk. In the background on the left is the new Atlantic Hotel Sail City, built – as the name would suggest – in the shape of a sail. It's part of Havenwelten, the new complex on Neuer Hafen. Outside the hotel the Seute Deern is moored, one of the exhibits at the German Museum of Shipping.

Left:
When Sail is on in Bremerhaven every few years – or even 'just' the Festwochen festival – Neuer Hafen is packed with all kinds of watercraft, from longboat to tall ship.

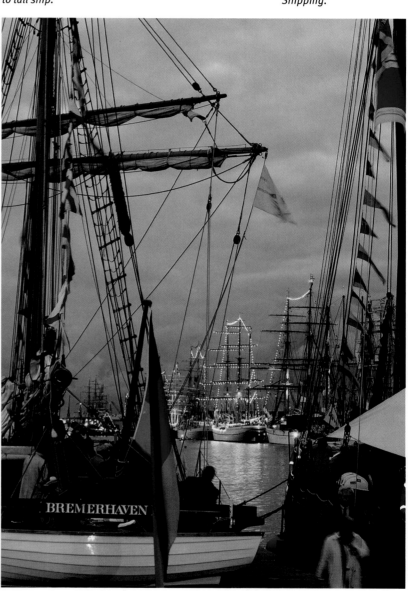

Above:
The tall ships that travel to Sail from all over the world are a particularly fine sight. When the sun goes *down over the city and the Outer Weser the ships are not only flagged from deck to top but also lit up with hundreds of fairy lights.*

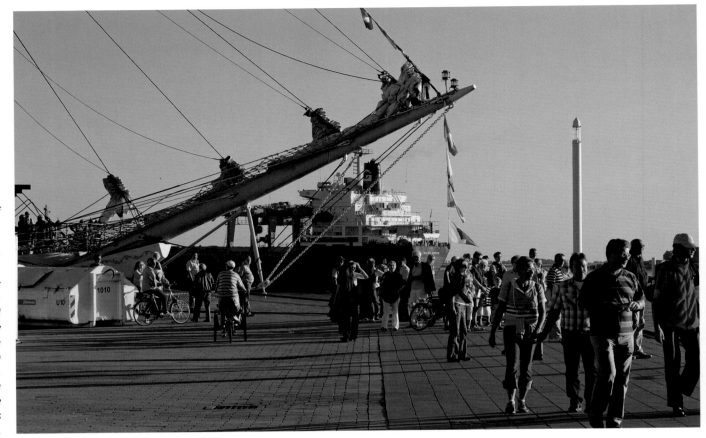

Right:
During the Festwochen and Sail the ships that are too big for Neuer Hafen are anchored in the deeper marine waters of the Seebäderkaje.

Below:
Old meets new in Bremerhaven. The city doesn't just come up trumps with tourists with its traditional ships; the brand-new Klimahaus, opened at the end of June 2009, is also proving to be a big hit. Here visitors can take a trip along the 8th degree of longitude that runs through the port.

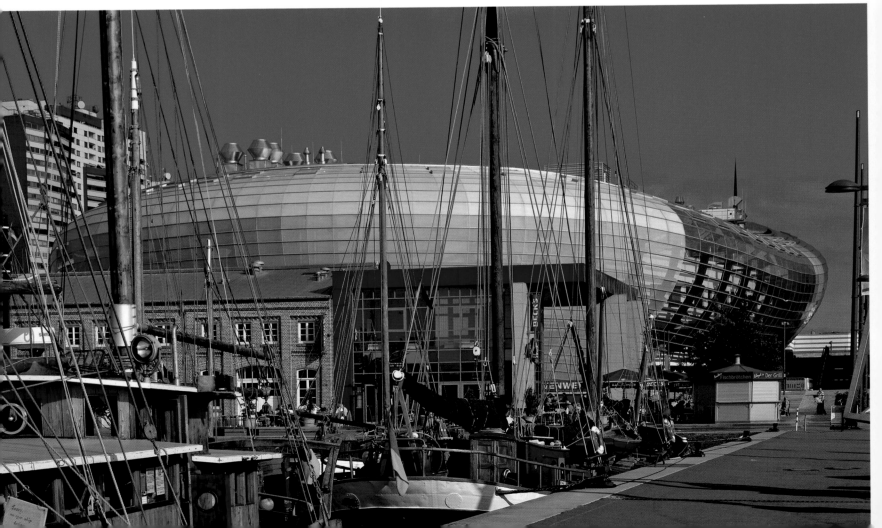

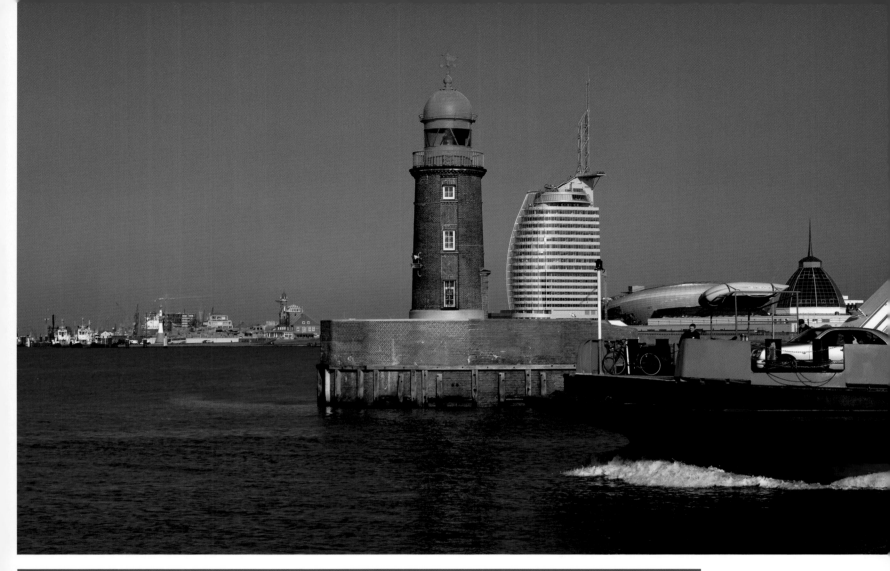

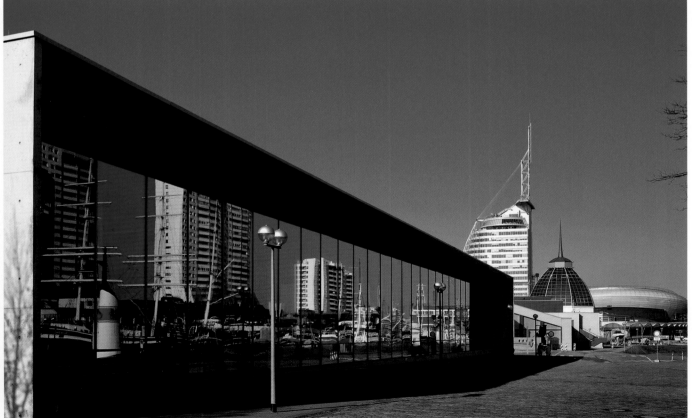

Above:
The mouth of the tiny River
Geeste once provided
Bremerhaven with access
to the open sea, as the
lighthouse indicates. The
estuary is now where
ferries depart for Norden-
ham-Blexen and where
the Hermann Rudolf Meyer
rescue cruiser and the
boats of the waterways
and shipping office are
berthed.

Left:
At the beginning of the
1970s a national research
centre and archives for the
history of shipping was
set up when the German
Museum of Shipping was
opened in Bremerhaven.

127

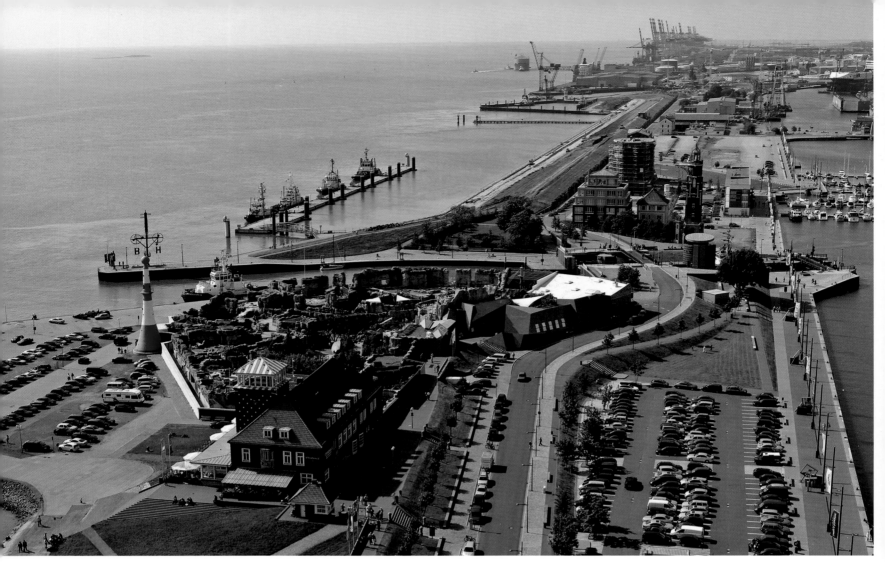

Above:
Bremerhaven has gone maritime! On the far left is the Seebäderkaje, with the centre of the photo showing the entrance to Neuer Hafen and the zoo. The latter, rebuilt a few years ago, gives visitors the chance to study in depth the many creatures of sea.

Right:
Bremerhaven's harbours have been made independent of the tides by installing a system of locks. The international ports are protected by the Kaiserschleuse and Nordschleuse. The fishing harbour is accessed via a double lock and there is also a lock monitoring the mouth of Neuer Hafen.

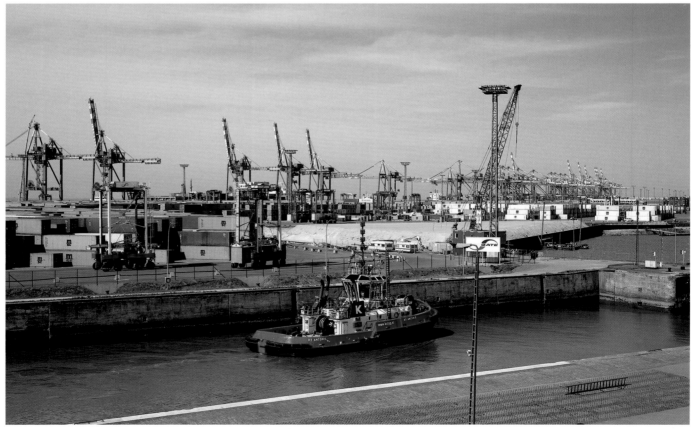

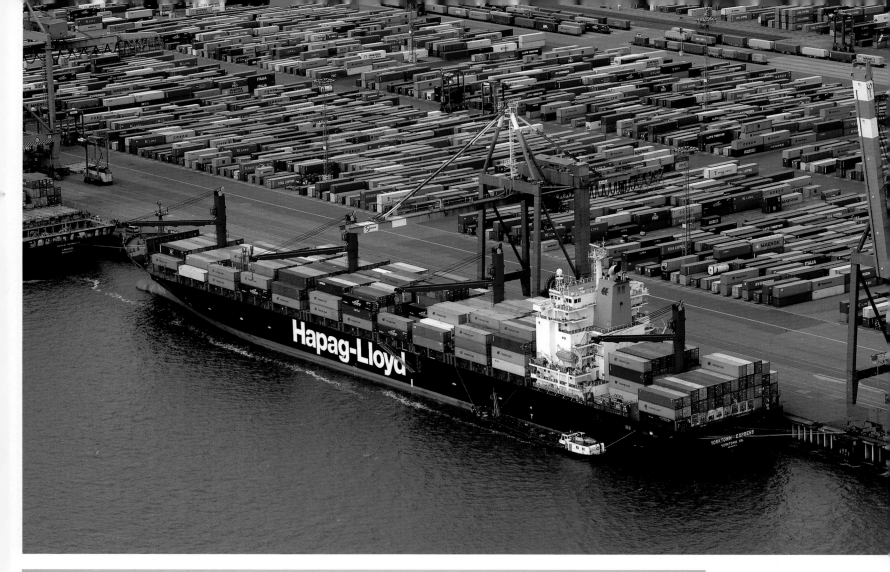

Above:
Containers have been unloaded on the quay in Bremerhaven since 1971. The first heavy machinery set to in 1968, with the final stage of construction – for the moment at least – completed in 2008. Five kilometres / three miles long, the Wilhelm Kaisen Terminal, as it's officially called, is the longest container terminal in the world.

Left:
Access to land at the north end of the international port is provided by a swivel bridge over the Nord-schleuse or north lock.

The harbour doesn't go to sleep at night. In the container business in particular time is money, meaning work goes on through the hours of darkness.

Below:
Communication at sea past and present. In the days when telecommunication was just a wild fancy, signal boxes on the banks of rivers and the North Sea estuaries were absolutely essential. This is now all done by electronics, with this new communications tower on the Geeste Estuary in Bremerhaven built for precisely this purpose.

Below:
Just in time for Sail 2005 the city of Bremerhaven was given a special treat: the semaphore signals on Neuer Hafen were reinstated on top of the Hohe Weg lighthouse. The mast shows the force and direction of the wind from Borkum and Helgoland.

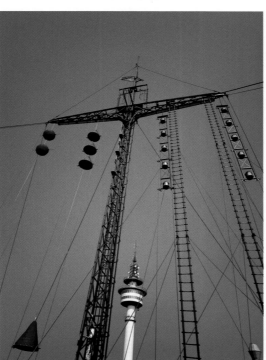

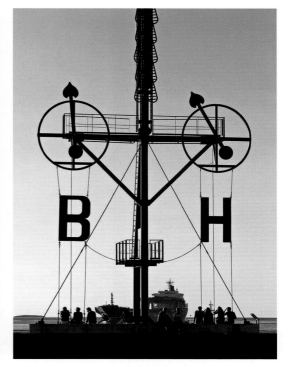

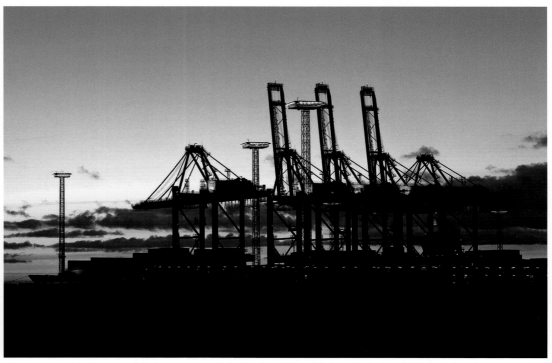

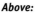

Above:
The future of container transhipping in Bremerhaven began in the 1990s when three super post-Panmax container gantry cranes were built for big ships during the extension of the Wilhelm Kaisen Terminal.

Page 132/133:
Sail in Bremerhaven wouldn't be the same without its fantastic fireworks display.

131

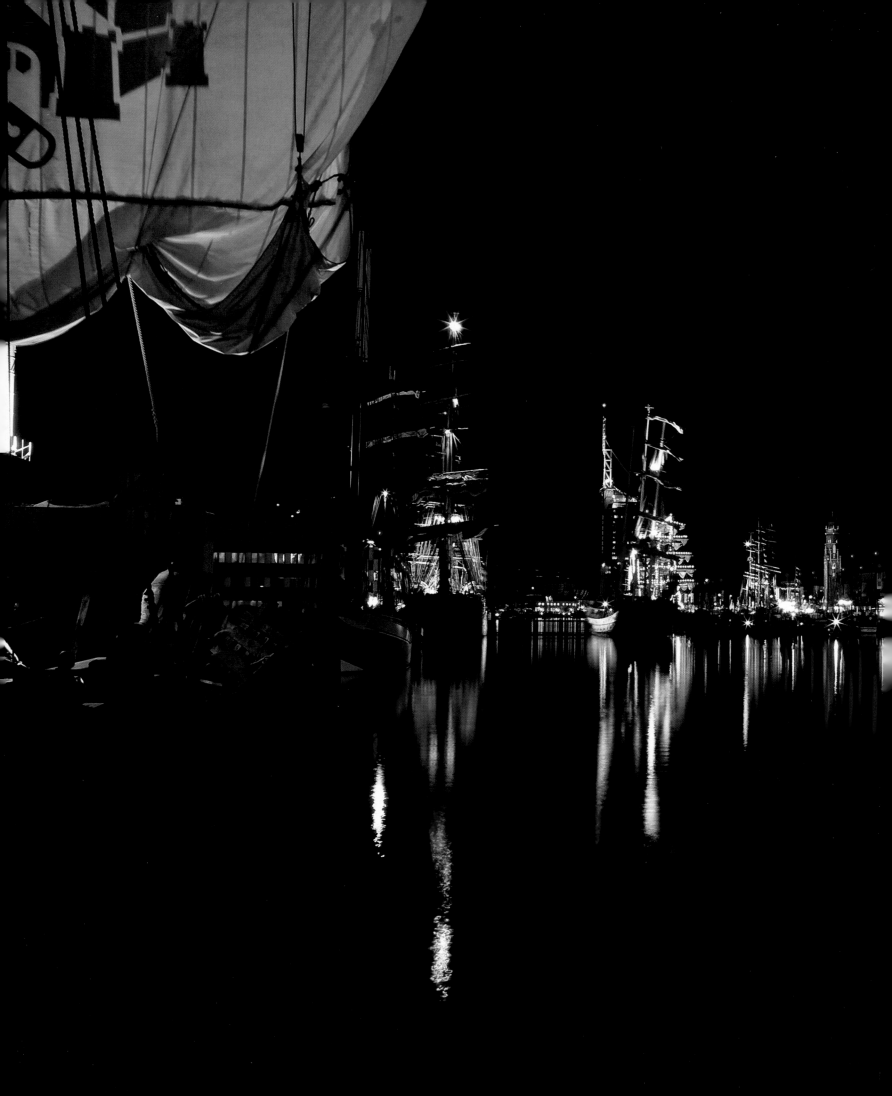

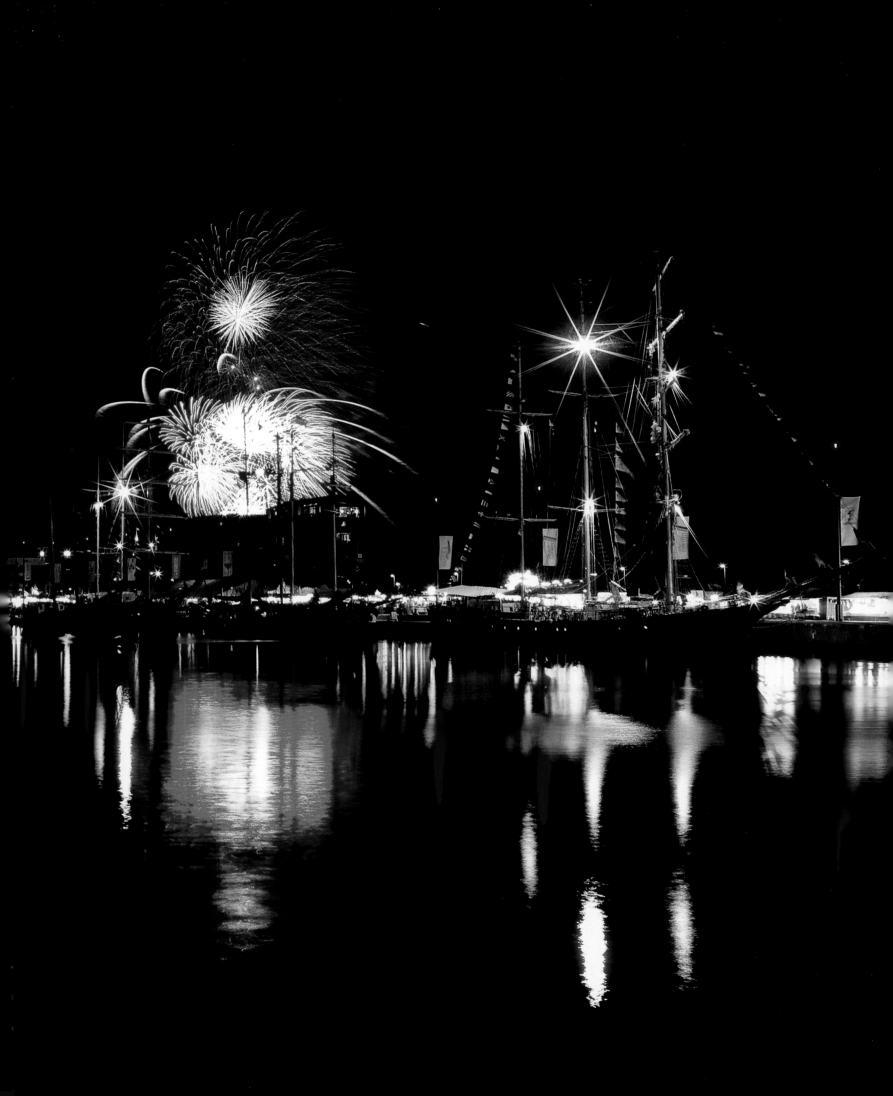

INDEX

.................................Text.....................Photo

.................................Text.....................Photo

Airport ..66
Alfred Wegener Institute..............120
Altenesch86
Alter Hafen120
Atlantic Hotel120120
Balge13, 14
Barkenhoff104, 114100, 101
Berne86
Blumenthal16, 17
Borgfeld21, 114
Böttcherstraße62, 6314, 15, 40–45
Brake86
Breites Wasser24, 25
Bremen Town Band1933, 35
Bremer Loch35
Bremer Schweiz86
Bremerhaven14, 19, 20,10, 11, 88,
.................................86, 120120–131
Bürgerpark21, 2668–71
Bürgerweide1570, 71, 82, 83
Cathedral1322, 23, 36, 37
City weigh house35
Colonial monument15
Columbus Centre....................12010, 11, 120
Delmenhorst86
Deutsches Auswandererhaus.....12010, 11
Elsfleth...................................86
Europahafen............................76, 77
Findorff..................................62
Fischerhude.............1148, 9, 102, 105, 114–117
Fishing harbour.......................128
Focke Museum........................1365, 92, 93
Freihafen II.............................14
Freimarkt...............................8082, 83
Geeste14, 120127
Geestemünde.........................19
German Museum of Shipping......120 ..10, 11, 120, 122, 123, 127
Grain harbour..........................65
Grain store79
Grohn....................................73, 90
Gröpelingen............................62
Grünzug West21
Hamburger Straße....................62
Hamme...................86, 10486, 99, 109
Handwerker-Hof.......................44
Hasenbüren............................8678
Haus Atlantis...........................63
Haus der Bürgerschaft..............2028, 29, 34, 35
Haus der Sieben Faulen.............43
Haus des Glockenspiels.............15, 38, 39
Haus im Schluh.......................104103, 108
Haus Mittelsbüren....................92
Haus Riensberg........................93
Haus Seefahrt..........................1673, 90
Havenwelten...........................120
Hermann-Böse-Straße...............62
Hoetger-Hof............................44
Hollersee................................70, 71
Höpkens' Ruh..........................21
Kaffee Verrückt (mad café)........104104–107
Klimahaus...............................12010, 11, 126
Knoops Park............................8695
Kunsthalle...............................15
Langenstraße...........................35

Lemwerder86
Lesum21, 86, 104.......18, 19, 94, 95
Lesumbrok94
Marktplatz (marketplace).........2626–29
Meierei69
Mittelsbüren94
Neuer Hafen (new harbour).....10, 11, 88, 122–126, 128, 131
Nordenham86
Oberneuland21, 114
Obernstraße53
Osterdeich1660, 62, 84
Osterholz99, 109
Ostertor26, 6252
Ostertorsteinweg.....................52, 60
Ottersberg114
Overseas museum1564
Parkhotel68, 70, 71
Paula-Modersohn-Becker-Haus ..6344
Quay129
Rathaus (town hall)14, 19,5, 12, 13,
.................................20, 2628–31, 34, 35
Ratskeller30
Rhododendron park2172, 73
Ritterhude99
Robinson Crusoe Haus63
Roland14, 19, 20, 26.......32, 35
Roselius Haus6342
Schlachte14, 26
Schloss Blomendal....................16, 17
Schnoor2646–51
Schütting1234
Schwachhausen.......................6258, 61–63
Seebäderkaje126, 128
Sögestraße52
Speicher VI harbour museum ...64, 65
Speicher XI20, 21
Speicherstadt76, 77
St Magnus21
St Martin95
Stadthalle (city hall)55
Stedinger Land8691
Steintor26, 62
Straßburger Straße58
Telecommunications tower........78
Teufelsmoor10486, 96, 97, 113
Theatre on Goetheplatz............54
Überseestadt1520, 21, 64, 76, 77, 79
Universum Science Centre.........67
Unser Lieben Frauen Kirchhof...37
Vegesack.................14, 86, 10418, 19, 89, 90
Wagenfeld Haus55
Wallanlagen............................2622, 23, 73–75
Wallmühle (windmill)75
Werderland94, 95
Weser13, 14, 16, 20,.......18, 19, 78, 79,
.................................26, 80, 120.......84, 85, 125
Wesermarsch86
Weserstadion85
Weyerberg17, 104108, 109
Wood and factory harbour.........78, 79
Worpswede17, 10486, 96, 97,
.................................102–113, 118, 119
Wümme..................86, 11486, 114, 115, 117
Zoo.......................................12010, 11, 128

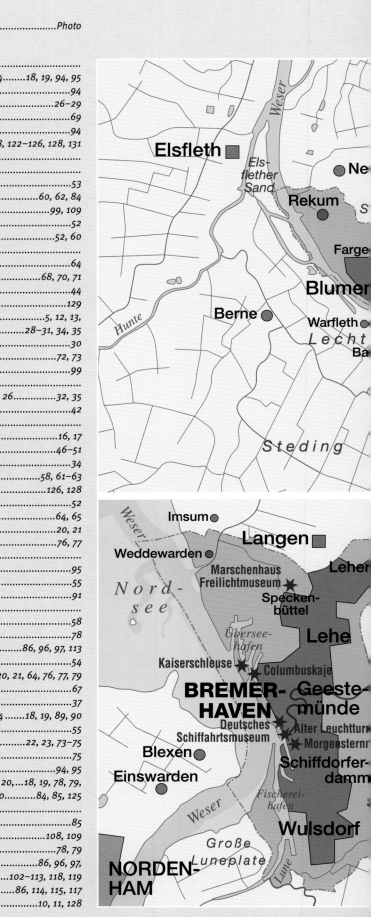

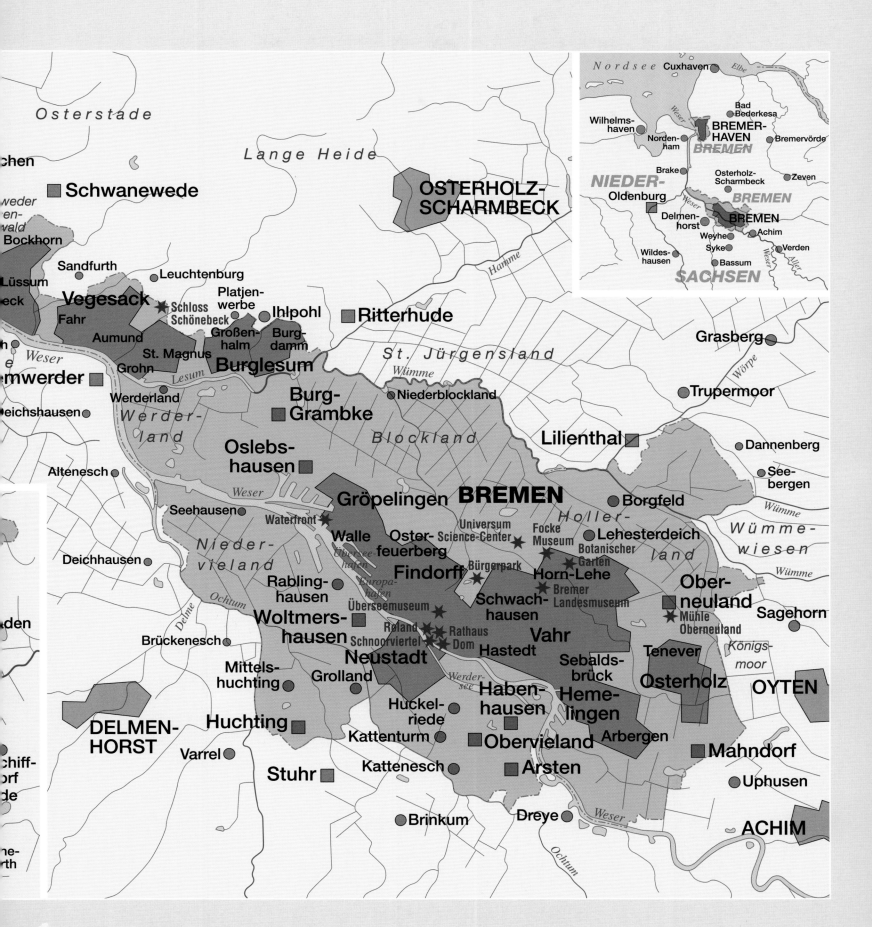

Osterstade

Lange Heide

OSTERHOLZ-SCHARMBECK

■ **Schwanewede**

Bockhorn

Lüssum

Sandfurth

Leuchtenburg

Platjen-
werbe

Vegesack

★ Schloss
Schönebeck

Ihlpohl

■ **Ritterhude**

eck

Fahr

Aumund

Großen-
halm

Burg-
damm

Grasberg

St. Magnus

St. Jürgensland

Grohn

Lesum

Burglesum

Wümme

mwerder ■

Weser

Werderland

**Burg-
Grambke** ■

Niederblockland

Trupermoor

eichshausen

Werder-
land

Blockland

Lilienthal ■

**Oslebs-
hausen** ■

Dannenberg

Altenesch

Weser

Gröpelingen

BREMEN

Borgfeld

**See-
bergen**

Wümme

Seehausen

Waterfront ★

Holler-

land

Wümme-

wiesen

Deichhausen

Nieder-
vieland

Walle

Oster-
feuerberg

Universum
Science-Center

Focke
Museum

★ **Lehesterdeich**

Wümme

Übersee-
hafen

Botanischer
★ ★ Garten

Rabling-
hausen

Findorff

Bürgerpark

Horn-Lehe

**Ober-
neuland**

Europa-
hafen

Schwach-
hausen

Bremer
Landesmuseum

Delme

Ochtum

**Woltmers-
hausen** ■

Überseemuseum ★ ★

Roland ★ ★ Rathaus

Schnoorviertel ★ ★ Dom

Vahr

★ Mühle
Oberneuland

Sagehorn

Königs-
moor

Brückenesch

Neustadt

Hastedt

Sebalds-
brück

Tenever

Mittels-
huchting

Grolland

Werder-
see

Haben-
hausen

**Heme-
lingen**

Osterholz

OYTEN

**DELMEN-
HORST**

Huchting

Huckel-
riede

Kattenturm

Obervieland ■

Arbergen

Mahndorf

chiff-

orf

Varrel

Kattenesch

Arsten ■

Stuhr ■

Weser

Uphusen

erth

Brinkum

Dreye

Ochtum

ACHIM

Nordsee Cuxhaven

Elbe

Bad
Bederkesa

Wilhelms-
haven

Weser

**BREMER-
HAVEN**

Bremervörde

Norden-
ham

BREMEN

NIEDER-

Brake

Osterholz-
Scharmbeck

Zeven

BREMEN

Oldenburg

Weser

Delmen-
horst

BREMEN

Weyhe

Achim

SACHSEN

Wildes-
hausen

Syke

Verden

Bassum

Aller

135

Happy cows graze the countryside near Bremen, such as this Frisian in the morning mist.

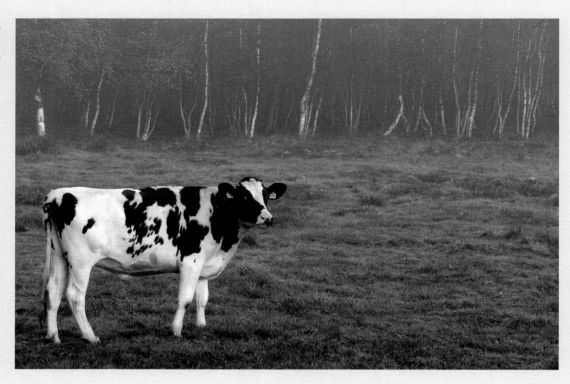

Design
www.hoyerdesign.de

Map
Fischer Kartografie, Aichach

Translation
Ruth Chitty, Stromberg
www.rapid-com.de

Printed in Germany
Repro by Artilitho, Lavis-Trento, Italy
Printed/Bound by Offizin Andersen Nexö, Leipzig
© 2009 Verlagshaus Würzburg GmbH & Co. KG
© Photos: Günter Franz & Benita Kapur
© Text: Ulf Buschmann

ISBN: 978-3-8003-4037-8

Photo credits
Günter Franz:
Front jacket, back jacket, p. 5,
p. 10/11, p. 12/13, p. 14, p. 15, p. 16/17, p. 18/19, p. 20/21,
p. 22/23, p. 24/25, p. 28-32 (5 fig.), p. 34 left top,
p. 34 right top, p. 35 (4 fig.), p. 36, p. 38-43 (6 fig.),
p. 44 right bottom, p. 45-48 (3 fig.), p. 50 left top,
p. 50 right top, p. 50 right bottom, p. 51, p. 52 left bottom,
p. 52 right bottom, p. 53-55 (4 fig.), p. 58-61 (6 fig.),
p. 64-67 (8 fig.), p. 72 bottom, p. 73-79 (11 fig.),
p. 80/81 centre, p. 81 top, p. 81 bottom, p. 82/83,
p. 84 top, p. 84 bottom, p. 85 top, p. 86-99 (18 fig.),
p. 108/109 (3 fig.), p. 120-133 (17 fig.).

Benita Kapur:
p. 8/9, p. 26/27, p. 33, p. 34 right bottom,
p. 34 right bottom, p. 37 top, p. 37 bottom, p. 44 top,
p. 44 left cetre, p. 44 left bottom, p. 49, p. 50 right bottom,
p. 52 top, p. 56/57, p. 62/63 centre, p. 63 top,
p. 63 bottom, p. 68-71 (5 fig.), p. 72 top, p. 85 bottom,
p. 100-103 (4 fig.), p. 104/105 centre, p. 105 bottom,
p. 106/107, p. 110-113 (4 fig.), p. 114/115 centre,
p. 116-119 (6 fig.), p. 136.

Details of our programme can be found at
www.verlagshaus.com